Women of Taste

A Collaboration Celebrating Quilt Artists and Chefs

IN ASSOCIATION WITH
GIRLS INCORPORATED®

EDITED BY JEN BILIK

PROJECT CREATED BY LYNN RICHARDS

FOREWORD BY JULIA CHILD

PREFACE BY ISABEL C. STEWART,
National Executive Director, Girls Incorporated

C&T PUBLISHING

©1999 Girls Incorporated

Developmental Editor: Liz Aneloski

Technical Editor: Vera Tobin

Cover and Book Designer: Christina Jarumay

Design Directors: Diane Pedersen and Kathy Lee

Published by C&T Publishing, Inc., P.O. Box 1456, Lafayette, California 94549

Library of Congress Cataloging-in-Publication Data

Women of taste: a collaboration celebrating quilt artists and chefs / in association with Girls Incorporated; foreword by Julia Child; preface by Isabel C. Stewart;
edited by Jen Bilik.
 p. cm.
 Includes index.
 ISBN 1-57120-078-9 (paper trade)
 1. Quilts—United States—Themes, motives Exhibitions. 2. Artistic collaboration—United States Exhibitions. 3. Food in art Exhibitions. I. Bilik, Jen. II. Girls Incorporated.
 NK9112 .W655 1999
 746.46'0973'074-dc21
 99-6295
 CIP

Printed in Hong Kong
10 9 8 7 6 5 4 3 2 1

This book has truly been a community project.

We are grateful to Todd Hensley, the publisher at C&T, who took only one lunch with us to see the potential in this book. Our work with the C&T staff has given us an even greater appreciation of collaboration.

The book's tasteful style and attractiveness has been a real gift of love thanks to Jen Bilik—artist, wordsmith, and devoted editor, compiler, and interviewer. Working with her has been a remarkable experience, and we thank Ann Rhode and Arielle Chu for their dual recommendations.

We want to acknowledge and thank all of the following contributors:

Eleanor Bertino, Sandi Cummings, Deanna Davis, Penny Nii, Sue Pierce, and Yvonne Porcella for their experience and wisdom during the project's preliminary stages.

Jean Atthowe, Edith Beard Brady, Rita Delgado, Carla Haimowitz, Carol Beth Icard, Geraldine Kuntz, Karin Lusnak, the Marcus family, Gwen McMillan, Iris Polos, Emily Rosenberg, Roberta Stern, Loraine Stern, Elizabeth Swarthout, Judy Tatelbaum, Landa Townsend, and Parris Vacek—friends and family who have listened, supported, and problem-solved throughout this process.

Crisley McCarson, project director at the Smithsonian Institution Traveling Exhibition Service, who has masterfully kept everything moving forward on the exhibition.

Judy Glenn, associate executive director at Girls Incorporated of Alameda County, who first suggested the concept of blending the culinary and art worlds.

Pat Loomes, executive director at Girls Incorporated of Alameda County, whose trust and encouragement have truly demonstrated that we can all be *strong*, *smart*, and *bold*.

Most of all, we want to acknowledge the quilt artists and women in the culinary arts who believed in themselves as collaborators and as women, and who were proud to work with us to further Girls Incorporated's identity and mission.

LYNN RICHARDS
KAREN WEHRMAN
Women of Taste Project Organizers

Acknowledgments

Contents

Foreword

Girls Incorporated performs a great service in this country by helping girls to plan realistically but confidently for their futures. With *Women of Taste*, one hundred two accomplished women bring two traditionally domestic arts from the sewing room and kitchen to the walls of museums and onto the pages of a book for everyone to enjoy. In pairing quilt artists and chefs, Girls Incorporated not only exposes us to examples of women following their creative and professional passions but also demonstrates the value of collaboration and cross-disciplinary alchemy. Both quilt artists and chefs select fine ingredients from all over the world and mix them up with inspiration, new ideas, and time-honored recipes, techniques, and materials. When people come together to exchange ideas and try new approaches, they cannot help but begin to think a bit differently, support one another, stretch and grow, and perpetuate a spirit of sharing and inquiry.

Girls Incorporated shows girls that they can be workers, wives, and mothers while fulfilling their fondest dreams. As more girls understand their potential, our culture becomes all the richer for this partnership of diversity, ideas, performance, and skill. In reading the stories in this book—the stories behind the quilts as well as the biographies of the participants—I am struck by how few of the women knew what they were going to be when they "grew up." By following palates, hearts, hands, and eyes, however, all have found their callings and supported themselves to boot. I believe we do best what we love most, and the rewards of following the heart are far greater than those of following the pocketbook. To all the girls and young women who draw inspiration from the grand women included in these pages, I say roll up your sleeves, follow your passions, get splattered, get trained, work hard, resist fads, share what you know, be nice, help others, and enjoy life.

—JULIA CHILD

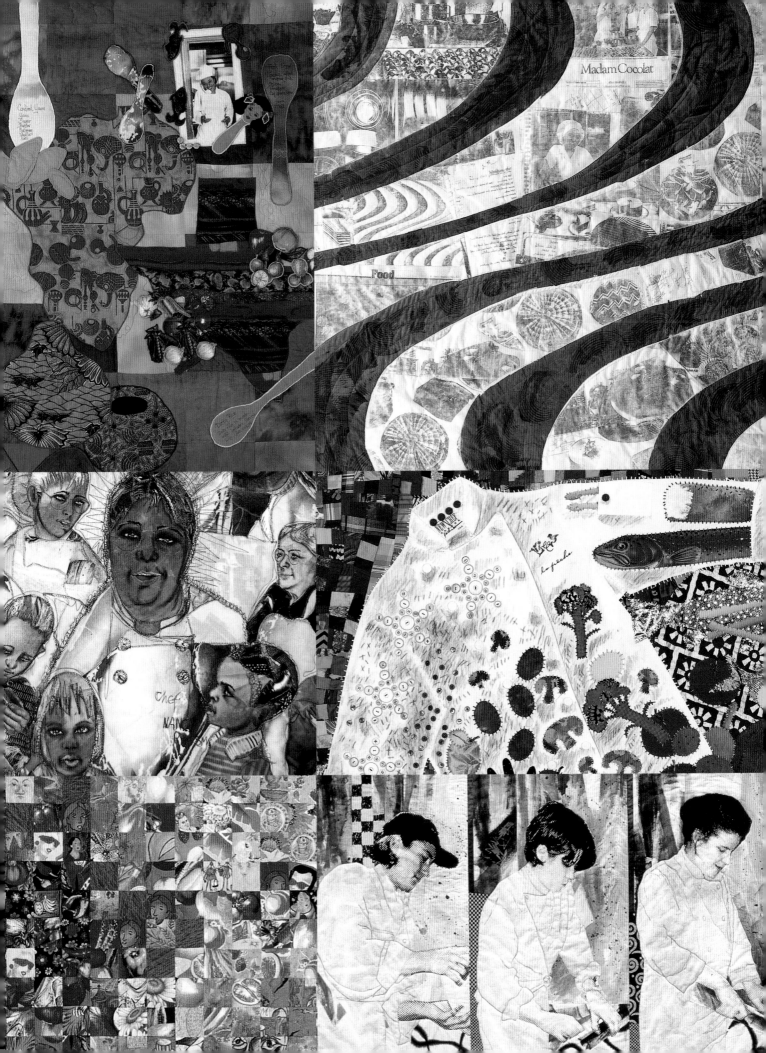

Preface

Girls Incorporated (Girls Inc.) has been a proponent of girls' rights ever since the very first "girls club" opened its doors in 1864. During the Industrial Revolution, young women from rural communities came in search of job opportunities in the textile mills and factories of New England. Early girls clubs met the needs of these young working women and the younger daughters of mill families who had no place to gather but in the city streets. The clubs provided a safe, nurturing environment where girls could enjoy the companionship of their peers and participate in cooking, sewing, knitting, dramatics, and swimming programs. The original Girls Clubs of America founders focused on two major goals: to exchange information on programs relevant to girls and to help communities establish new centers.

Roles for girls and women have changed dramatically over the years and so has the Girls Inc. mission, which now works to inspire all girls to be strong, smart, and bold. In 1990, the organization changed its name to reflect a greater emphasis on research-driven programs that build girls' skills and self-confidence, and Girls Inc. reaffirmed its commitment to ensuring every girl's right to express herself, take risks, live free of self-doubt, and prepare for fufilling work and economic independence.

Girls Inc. programs are currently delivered to girls ages six to eighteen at over one thousand sites nationwide through Girls Inc. affiliates, neighborhood centers, schools, and program partners. Affiliates strive to nourish and strengthen the minds, bodies, and spirits of girls through research-based programming, vigorous advocacy, and daily, year-round contact.

Girls Inc. of Alameda County, California distinguishes itself as a leader in providing girls with the tools and motivation to become their own best advocates. The organization's bold approach to careers and life planning, leadership, adventure, and health lead to girls who know and are not afraid to exercise their rights. Girls Inc. of Alameda County helps to transform the lives of countless girls—most of whom face serious social, financial, and emotional obstacles. Through its annual Women of Taste event, this venerable affiliate epitomizes the spirit of bringing girls and women together to create lasting change in the community and in girls' lives. The event, this exhibit, and the book have been created to showcase women and their careers and stand as one of the most creative and successful examples of fundraising and consciousness raising nationwide.

Girls Inc. is honored by its Alameda County affiliate whose passionate pursuit of girls' rights opens a world of possibility for girls in the Bay Area. May every girl who is touched by her experiences at Girls Inc. of Alameda County bring strong, smart, and bold energy with her into the world, allowing others to experience its powerful presence.

ISABEL C. STEWART
National Executive Director
Girls Incorporated

The Women of Taste event was first envisioned, appropriately, in cooking school. Karen Wehrman, a board member of Girls Incorporated of Alameda County, had decided to leave her career in real estate to pursue a lifelong dream. During her eighteen months at a culinary academy, she noticed a special kind of camaraderie among the women students as they worked together in the kitchen. She was eager to create a benefit for Girls Inc. that would bring together the Bay Area's finest women chefs and restaurateurs to showcase their creations. Today, Women of Taste is an annual event that contributes significantly to Girls Inc.'s results-driven programs, which change the lives of girls and young women every day.

Once Women of Taste was established, Lynn Richards, the program developer at Girls Inc. of Alameda County and a quilter herself, began to solicit quilt artists nationwide to create quilts to display at the event. The quilts focused on women's interpretations of their relationships with food. The theme sparked great interest, and event attendees were delighted to view the results as they sampled their gourmet treats.

The next step was bold. Realizing that Girls Inc. could benefit further from the fact that the domestic arts had come out of the home and into the spotlight, Karen and Lynn decided to bring the visual and culinary worlds together by pairing nationally known women quilt artists with nationally known women in the culinary arts. The individual pairs were to collaborate in creating quilts based on personal and professional ideas about food, food-related issues such as the environment, agriculture, and health, and aesthetics, careers, family, and creativity. Through these chef and artist pairs, they were hoping to expand that same female connection

Karen first noticed in cooking-school kitchens. Luminaries in the quilt and culinary worlds warmly accepted the invitation and matches were made, generally with geographical proximity in mind. While some artists and chefs matched themselves with friends, pairs were often complete strangers to one another and in some cases lived thousands of miles apart.

Based on the tremendous success of the Full Deck Art Quilts show, currently on tour through the Smithsonian Institution Traveling Exhibition Service (SITES), we consulted with that project's organizer, Sue Pierce. She encouraged us to submit a proposal to SITES. To our delight, the SITES staff reported, "Women of Taste just resonated with all of us."

One last component remained—while the quilts would stand as visual testimony to each pair's work, we also wanted to present the remarkable stories of the collaborations. C&T Publishing was visionary enough to share our interest in these tales and move forward with our concept for a book, allowing the stories of these incredible relationships to be heard.

As you examine the quilts and read through these stories, we trust you will be as enchanted as we have been with the nature of the collaborative process in all its glorious variety. We are so proud and so eternally grateful to all the quilt artists and culinary mavens who have pooled their collective stories and creative forces to create this tribute to all women of taste—past, present, and future.

PAT LOOMES
Executive Director
Girls Incorporated of Alameda County

Women

We are fortunate to have included in this project many of the top quilt artists and chefs in the country. Yet, with this embarrassment of riches, mention of specific accomplishments such as awards, exhibitions, and restaurant stars became very repetitive. In keeping with Girls Inc.'s mission of exposing girls and young women to the wonderful variety of available life options, we have chosen instead to focus on the professional and creative paths of the chefs and artists. Though we have not listed teaching, lecturing, and writing activities individually, most of the artists and many of the chefs teach and conduct workshops in addition to their quiltmaking or cooking. ◆ The text about these collaborations was compiled from many sources: project journals, notes, and descriptions, and correspondence, personal statements, and interviews. ◆ Note: Width precedes height for quilt dimensions.

"Once again, I find myself trying to stitch the world back again, trying to save it ALL, one stitch at a time! . . . and so my fellow quilters, we all sew; *we stitch our messages both formal and free.* Let us not judge each other too harshly outside the context of a quilters' competition. Let us instead rejoice in our various textures, our many skills. Life has burdened all of us enough with schools of this and schools of that. Our quilting is one area of our lives where there is room enough for all—one area where the piece is as big as we want to make it. This is our arena. This is our art. This is the space where we can be free."

—Penny Sisto, *American Quilter*

of Taste

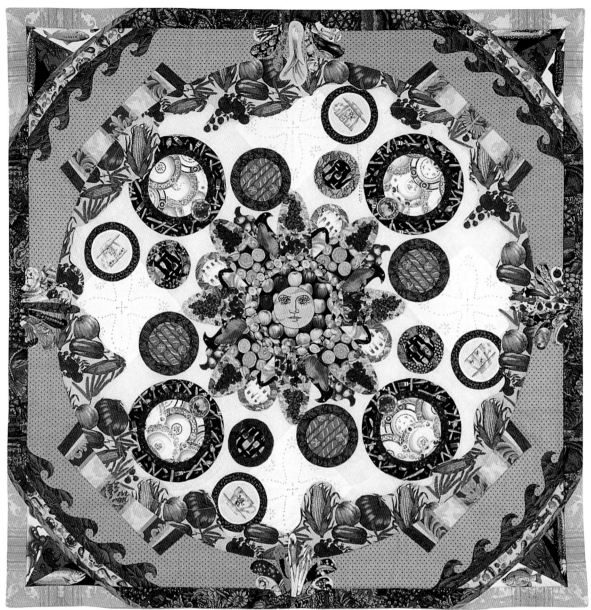

TERESA BARKLEY ◆ LIDIA MATTICCHIO BASTIANICH

BLESSED BY THE SUN

59 x 59 inches
Linen and cotton fabrics, and
embroidered linen squares from the 1940s.
Hand appliquéd, machine pieced,
machine quilted, and hand embroidered.

I presented Lidia with my idea of depicting an overhead view of a table. She responded with masses of material for inspiration. She sent pictures to illustrate the techniques of perspective used in Renaissance painting; fantastic upholstery tapestries with floral, fruity, and geometric imagery; hand-embroidered squares of white linen that were perfect for the table-cloth; a ceramic sun that inspired the face you see in the center of the quilt. Lidia told me that the hierarchy of food in the Middle Ages gave the highest status to food that grew closest to the sun. With that in mind, I designed the quilt with the tree-grown food radiating from the center, and food that comes from underground or in the sea around the edges.

n working with Lidia, I discovered how similar her relationship with food is to my relationship with fabric. For each of us, our chosen medium is part of almost every aspect of our lives. I do no food preparation at home; my husband does all our cooking. I focus on sewing. Whether I'm pattern making for my day job or quilting on my own time, I'm thinking about fabric. I think of Lidia as equally focused on food. ◆ When I asked Lidia how she thinks up new dishes, she said, "A new product may stimulate me, or an idea for a dish may come from the reason for preparing it—a person, a season, or to satisfy myself." But, said Lidia, "Recipes endure. I don't change the cuisine, because I respect the culture. That's where I get my energy. I make modest modifications in my short period of time [on Earth]. I need my culture, and I respect my culture. I don't reinvent tomato sauce." When I quilt "the fabric decides what it wants to be." After I told this to Lidia, she responded with enthusiasm, saying it was very much the same with food, which "decides what route it wants to take." ◆ Some quilt artists work through an idea, letting it evolve as they go. I take an opposite approach. I usually plan a design in a full-scale pattern before I begin to cut fabric. There are two reasons for this: first, I take my inspiration from the fabrics I use, frequently working with "found object" materials or vintage textiles (which cannot be replaced), so I want to know before I cut how I will use the materials; and second, I am a pattern maker by profession. I find my two careers complementary—when I work on a dress pattern during the day, I am a technician executing the designs of someone else. When quilting, I employ many of the same tools, but I have the freedom to use any fabric or design I choose. Just as I love the excitement of putting new fabric combinations together, so it is with food for Lidia—rather than just following a recipe, the experimentation is wonderful.

—TERESA BARKLEY

TERESA BARKLEY lives in Maplewood, New Jersey. Her education is in fashion and textile design, and she supports her family as a patternmaker in the dress industry. She decided to make her first quilt when she was five, after learning that her great-grandmother's beloved quilts would probably go to the oldest child in the family rather than to Teresa. Her quilts merge traditional craft with contemporary themes, and include a series executed in large-scale postage-stamp format.

LIDIA MATTICCHIO BASTIANICH is co-owner of three New York City restaurants—Felidia, Becco, and Frico Bar—as well as Lidia's, in Kansas City. Born in Istria, she learned the secrets of Northern Italian border cuisine from her grandmother and came to New York City in 1958. She and her husband opened their first restaurant in 1971, and two years later Lidia took over the kitchen from the hired chef. Lidia is also a food historian, author, and television personality.

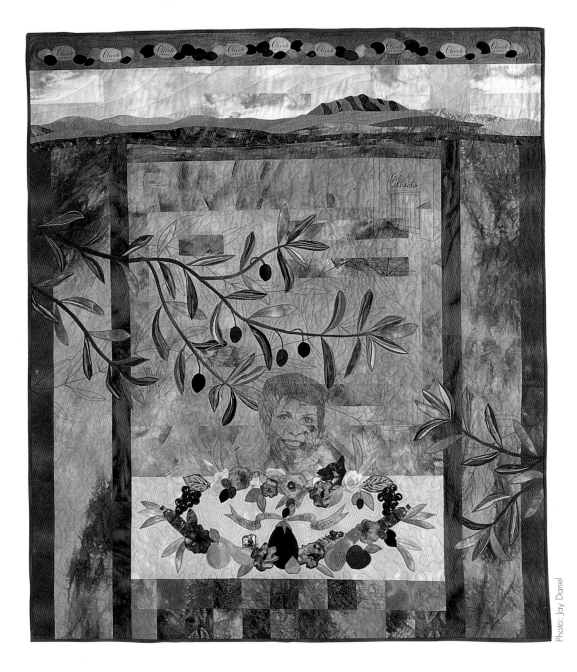

Photo: Jay Danel

JOAN BASORE ◆ MAGGIE BLYTH KLEIN

IN AN OLIVE GROVE WITH MAGGIE

52 x 59 inches
Cotton fabrics. Hand dyed, painted,
and drawn. Images photo-transferred.
Machine appliquéd, machine pieced,
and machine quilted.

Maggie and I were happy to realize that we share many interests:
gardens (we each cook from our gardens); the landscapes of
California and the Mediterranean; simple, fresh food; sustainable
agriculture; community involvement; local farms; and an artisan's
approach to work. One of Maggie's areas of expertise is olives, and
the olive tree is a favorite image of hers. Maggie appreciates a muted
but rich palette of browns, greens, golds, and gray browns. Color is
the one thing that has consistently kept me quilting. I dyed the fabrics
to correspond to Maggie's chosen spectrum. As I got to know Maggie
and visit her restaurant, I approached the design as a loose portrait.

14

The cooking I like most is authentic cooking—either the food tastes like itself, using the best (usually traditional) methods for extracting its essence, or the food's characteristics are complemented by the flavors and textures of other foods. Italian and French cooking are my favorite cooking styles by far. I find that new blendings of East and West are not all that successful (like a mango, foie gras, and pancetta concoction I recently heard about). I enjoy combinations that are prescribed by a location, such as rosemary, thyme, and garlic with lamb; figs; and fennel ice cream. When eating by myself, I usually just eat a big plate of whatever is in season. ◆ Of the exotic places I've traveled to, I like Tuscany the best, but I also love the arid, low-lying landscape of California. My favorite spot is on Tomales Bay at Inverness, with the view encompassing the barren hills and the wonderful birds. ◆ The pleasures of my business are nearly equally divided among offering well-prepared foods in a joyful and handsome place, being able to support small local organic farmers, providing a good living and a healthy and happy working place for my staff, whom I love, and being a contributing participant in our community.

—MAGGIE BLYTH KLEIN, *excerpts from a letter to Joan Basore*

Both Maggie and I grew up in Southern California, and when she told me her favorite image was that of an olive tree, I immediately pictured the beautiful groves of olive trees at the Villa Cabrini convent in Burbank. As a child, I always watched for the trees when we drove out of town, though I'm sure they're long gone now. Maggie hates ostentation, so I decided the quilt should feel quiet, with a design loosely based on an Amish central square. At the top of the quilt is a view across Tomales Bay from Inverness, which is Maggie's very favorite place. The lush pictorial style represents the complexities of Maggie's personality and accomplishments. An olive branch makes a reference to Maggie's restaurant and to her love for olives. While I was working on the quilt, I truly felt as if Maggie was with me, as if I'd been living with her. At the beginning I feared I wouldn't be able to translate such a wonderfully interesting person into a visual medium, but somewhere along the way I became comfortable with illustrating a few sides of her persona, and I'm sure what I chose is as much a reflection of me as of her.

—JOAN BASORE

JOAN BASORE lives in San Anselmo, California. She taught elementary school, specializing in outdoor education, and for many years has been a docent in a bird and native-plant sanctuary. Many of her quilts are based on nature. She began making quilts as bedcovers but grew tired of the repetition of patchwork blocks, ran out of beds, and began to experiment. She is largely self-taught by trial and error, reading, workshops, and help from friends.

MAGGIE BLYTH KLEIN is co-owner of Oliveto Cafe and Restaurant, in Oakland, California. After attending the University of California, Berkeley, Maggie worked as an editor in various university departments. In her spare time, she showcased her interest in food as a freelance writer. In 1986 she and her husband were inspired to open Oliveto after travels in Spain, Italy, and France. Maggie is the author of *The Feast of the Olive: Cooking With Olives and Olive Oil.*

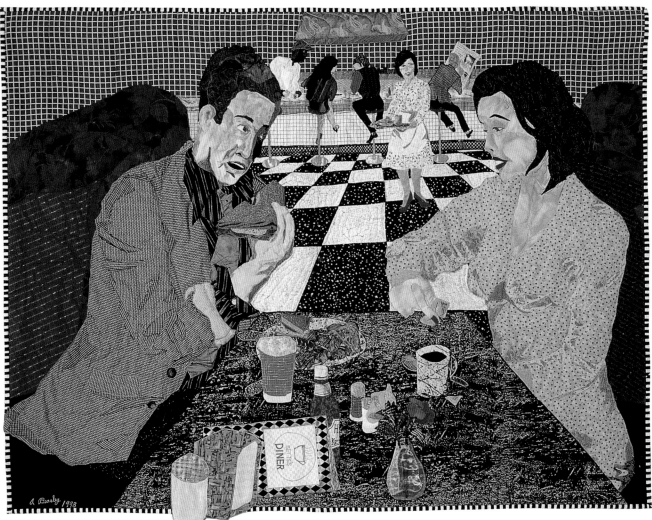

ALICE M. BEASLEY ◆ BETTE KROENING

BETTE'S DINER

59 x 45 inches

Cotton, blended, and sheer fabrics. Machine appliquéd, machine pieced, and machine quilted.

My collaboration with Bette clicked right off the bat because I was already a big fan of Bette's Oceanview Diner, and I had been thinking for years about making a diner quilt to reflect that very American way of eating. When Girls Incorporated gave me her name, I said, "Wow, this is like karma!" Bette and I met at her restaurant, and I took photographs of her, the diner, and the customers. I'd already created a mock-up and selected some swatches, which Bette loved. She also appreciated photos of some of my other quilts. I said, "Well, this is working!" and there was nothing to do but execute my quilt after that.

Bette's Oceanview Diner is the visual epitome of the diner, with its red counter stools, red booths, and black-and-white checkerboard floor. Although I took some liberties in my quilt (for one thing, Bette's Diner is always *much* more jammed than this—the line starts forming for breakfast around 6:25 A.M.), I think the essence is here. This quilt is also a commentary on the eating issues that frequently divide men from women in this society—the male diner enjoys Bette's purple pickled onions and tuna melt with home fries, but his companion consumes only coffee and Sweet 'n Low. Fortunately, Bette (in the middle ground) is coming to the rescue. She's not going to let that woman starve—she's bringing her Bette's food. Save that woman! ✦ Bette's Oceanview Diner is a very straightforward, down-to-earth, real place where you see professors and poets, pundits and punks, students and starving artists, builders and businessmen, neighborhood regulars, and tourists with maps, guidebooks, and reviews in hand. Bette calls the atmosphere "counter culture!" I wondered what Bette herself would be like, and when I met her, I discovered that she's a very straightforward, down-to-earth, real person—no conflict there! In fact, the only wrinkle in making this quilt was that my first iteration of the top pictured the man eating a hamburger and french fries, and the woman staring at a strawberry soda. It looked great! I'd finished the top and was about to start assembling, when I thought, "Wait a minute, I don't think Bette's serves these foods!" I went to Bette's, and sure enough, not a hamburger in sight, not a french fry in sight. To me, hamburgers and french fries are such typical diner fare, but that's not Bette. I had a real tug about what I should do, whether my obligation was to truth or beauty. So I actually brought this thorny ethical dilemma up with my sewing group. They said, "You can fool with the colors, you can fool with perspective, you can fool with all the visual stuff, but you can't fool with her food." So I changed it all to reflect Bette's menu, creating a tuna melt, home fries, pickled onions, and coffee. All the while Bette was out of the country and unreachable. Just before I had to turn the quilt over to Girls Incorporated, I finally contacted her and we arranged that I would bring the quilt over for her to see. She was bowled over by it—she just loved it!—and when I told her about the food crisis I'd had, she said, "Oh, you didn't need to change it!"

—ALICE M. BEASLEY

ALICE M. BEASLEY lives in Oakland, California. By day, she works as a lawyer with her own practice. She has always sewn and done various crafts. About ten years ago, she had the notion that, like paint, fabric could be used to create realistic scenes, but didn't know exactly how. One day she saw an article by Deidre Scherer explaining the right techniques, and she was off and running. In fact, the sweater she was knitting at the time is still only half-done.

BETTE KROENING is chef and owner of Bette's Oceanview Diner, in Berkeley, California. As a child she learned to cook in the kitchen of her family's summer camp. While employed as a social worker she studied cooking with Joyce Goldstein, and in 1982 opened Bette's to provide locals with a place to eat. The first thing purchased for the diner, even before a stove, was a jukebox. Operations now include Bette's To Go, a line of food products, and a cookbook, *The Pancake Handbook.*

JEANNE BENSON ◆ KATELL THIELEMANN

HEART OF KATELL

55 x 55 inches
Cotton and linen fabrics. Machine appliquéd,
hand pieced, and machine quilted.

Before I met Katell, I was working on a series of small quilts illustrating ingredients to recipes. I thought at first that I might illustrate one of Katell's favorites, but soon found that I was most drawn to stories of her childhood in Brittany. As a result this quilt became something very different. It incorporates a collection of relevant symbols: the cross at the center; the ermine, a symbol of the dukes of Brittany; a garland of hydrangea petals, a Breton favorite; and the triskelion, a symbol of Brittany (representing "the sea flowing 'round their hearts"), in a repeat pattern along the bottom. Also pictured are Katell's favorite herbs: thyme, rosemary, oregano, savory, and lavender flowers.

This quilt is more about Katell the child learning to be a cook than about any work she has done as an adult. Katell grew up in a fervently Catholic family on the west coast of France. Her family owned a restaurant, so she learned to cook at her father's knee. Her father had only daughters, and he believed it was very important for them to know a skill so they could always take care of themselves. Cooking was the skill he passed on to them. Katell's mother "held the purse" and worked in the front—the restaurant rather than the kitchen—and the family lived upstairs. Katell describes her father as a prima donna in the kitchen who once refused to prepare a meal when a diner requested that her meat be over-cooked. Katell's mother was called in to make the dish for the customer. ◆ I began to think of Katell as a landscape, and out of that landscape came the image of the cross. I have romanticized Katell's years in Brittany, and I was especially moved by the whole idea of a little girl growing up and working next to her father, learning skills traditionally reserved for men. I also fell for the colors of Brittany—the Breton blue, the pink stone, and the gray skies, granite, and slate. Through my research, I also found three quotes that inspired me:

Nature's achromatic scale puts the Brittany blues into high relief.
—Pierre Deux's Brittany

Deep in the heart of the countryside, the wind still smells of the sea.
— Pierre Jakez Hélias

Good color sings. It is melodious, aroma-like, never overbaked.
— Henri Matisse

◆ Setting up a design problem to solve is my favorite part of this whole process. Research is my second-favorite part, and sometimes the actual sewing is my least favorite. That surprised me when I realized it! ◆ With my ongoing series of recipe quilts, I find that gathering information to solve a design problem is similar to taking all the ingredients needed to make a particular recipe from the cupboard. No matter who we are (doctors, lawyers, merchants, or a chief), where we are (geographically or mentally), or what we do (work or play), all of us at some time find ourselves with a list of ingredients in our hands and we must contend with the recipe. For Babette in Isak Dinesen's novel *Babette's Feast*, making the recipe was the fullest expression of her passion and her art. For most of us, it's simply a means to an end when we're hungry. For me, the recipe spells out the ingredients—fabric, a quiltmaker's most valuable tool of expression—and an arrangement of color, texture, and shape.

—JEANNE BENSON

JEANNE BENSON lives in Columbia, Maryland. She was trained as a studio artist in college. She had no idea that an early job patternmaking and applying letters and images at a sign company would someday help her with appliqué techniques. When she attended a quilt show in 1978, she knew she had found her medium, learned how to sew, and has been a quiltmaker ever since. She is the author of *The Art and Technique of Appliqué*.

KATELL THIELEMANN lives in White Hall, Maryland. She studied international business in both France and the United States, and is currently working toward a law degree to assist her in business. As a student in Towson, Maryland, she was hired by the owner of Café Troia to draw upon her childhood cooking skills and work in the kitchen. Four years later, she partnered with him to open a restaurant at Baltimore's Walters Art Gallery.

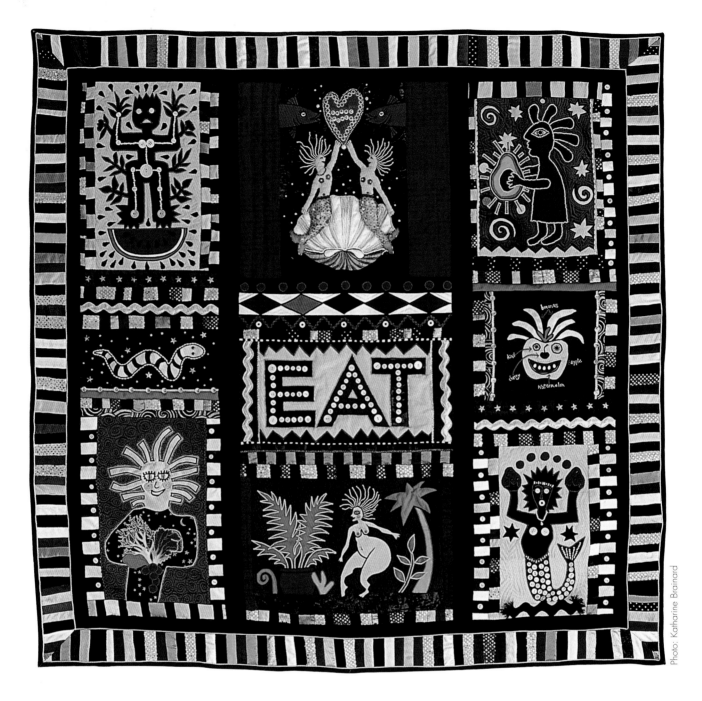

KATHARINE BRAINARD ◆ TRACI DES JARDINS

EAT

59 x 58 inches

Cotton and synthetic fabrics, buttons, beads, and various trimmings. Machine appliquéd, machine pieced, machine quilted, hand embroidered, and hand embellished.

During visits to Traci's restaurant, Jardinière, I watched her amid the kitchen commotion, as I sketched and photographed, talked with the staff, and then experienced an amazing meal with friends. The restaurant itself is very theatrical, with velvet curtains, marble floors, and rose-colored glass sconces. In the quilt, I've incorporated the colors of the restaurant: earthy aubergine, maroons, fleshy pinks and salmons, mauve. The glittery elements of the quilt echo the ceiling above Jardinière's bar, which is like an inverted champagne glass—or a galaxy of twinkling lights.

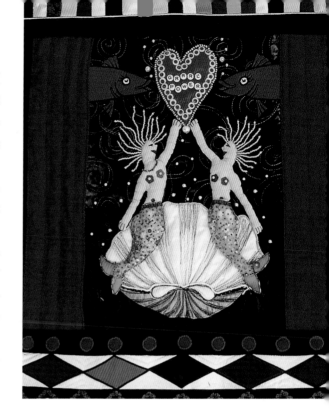

Eat was a difficult quilt to make. I had an eating disorder when I was younger, and I am sensitive to the problems of girls and women who struggle with food issues. We must eat in order to live. Food is a basic and fundamental necessity, but it takes on all kinds of meanings—nurturing, sexuality, growth, denial, self-love, self-hatred, even life and death. Food and eating produce emotions and physical reactions both gentle and strong. Food can soothe us, but it can also make us sick. Food can fill us and leave us satisfied or nourished, but it can also kill us. This quilt goes beyond the surface of food and eating, beyond preparation and presentation, reaching instead for the more essential and basic elements of food, the cycles of nature and life: fertilization, birth, growth, death. ◆ I think of Eat as sensuous and tactile, a visual smorgasbord. With luscious fabrics like velvets, silks, satins, and taffetas, it's reminiscent of a traditional crazy quilt. I used many small pieces of glittery fabric—gold, silver, and copper—with gold stars and beads to spice up the quilt and give it some light, make it dance and come to life. Each of the eight perimeter blocks depicts a humanoid form relating somehow to food. The mermaids at the top hold a heart that says "GRRRL POWER" to honor the girls this project benefits. At the upper left is a goddess from whom seeds emanate, which alludes to the process of beginning growth in both plants and humans. At the upper right is an avocado goddess with a lot of energy surrounding her. The snake at the middle left makes reference to the fruit temptation in the creation story of Adam and Eve, and also resembles a sprouting seed laying sideways. The middle right block was designed by my ten-year-old daughter, Katie, the reason I agreed to be a part of this project. At the lower left is a sun-related goddess who is offering up different lettuces and vegetables with a sly smile that could be friendly, could be not. The mermaid at the lower right opens her strawberry hands above her head to make a sort of magic. The lower middle block depicts a woman who is older and wiser than the young mermaids above. She dances through a garden to honor Traci and her restaurant (jardin means "garden" in French). "EAT" in the quilt's center is an invitation, a challenge, and a dare.

—KATHARINE BRAINARD

KATHARINE BRAINARD lives in Bethesda, Maryland. In 1982 her husband bought her some fabric when she was pregnant and in bed with the flu, and she figured out how to make a quilt her own way. Her second quilt won a prize in a church competition, but one of the judges advised learning basic sewing techniques so Katharine took the judge's class. She feels her creations became art quilts during her divorce, when they began to express emotion.

TRACI DES JARDINS is chef and co-owner of Jardinière, in San Francisco. She was raised amid rich California farmland, and her family, of French and Mexican descent, took pride in eating well. Soon after starting college, she realized that her calling was food, and began apprenticing in restaurants at the age of seventeen. Before opening Jardinière, in 1997, she worked in highly regarded kitchens in both the United States and France. Her first word as a child was "eat."

Photo: Dennis Griggs

ELIZABETH A. BUSCH ◆ DEBORAH HUGHES

WHITE CHOCOLATE CRÈME BRULÉE

53 x 54 inches

Cotton canvas, cotton fabric, satin ribbon,
and gold leaf. Hand painted and airbrushed.
Hand appliquéd, hand quilted,
and hand embroidered.

I had dinner at Deborah's restaurant and was amazed by her white chocolate crème brulée, a work of art in itself—a miraculous texture of satiny smoothness, exquisitely presented. I never before tasted such a creation, and I long for it again . . . on an emptier stomach. Deborah and I are both single parents with two children—our families are represented by the three rectangles in the background. The large triangle is symbolic of woman and of coming together in a kind of a unity. The colors are warm because that was the way I felt about our family affinities and about the whole experience.

As I started this project, I thought, How on earth could I create a quilt with references to food and in collaboration with a chef? What a challenge . . . and I love challenges. Would I begin for the first time to use realistic imagery in my work? What had I gotten myself into? Initially, all I had were questions. But then, as I do with all my work, I tried not to think about it, not to have any preconceived ideas, to stay open to any and all possibilities. ◆ I went to Deborah's restaurant to meet with her and sample her creations. The setting of UpStairs at the Pudding, in the old dining room of Harvard's historic Hasty Pudding Club, was vintage Cambridge, suggestive of old Boston, and with a certain level of conversation about important things. Original antique posters adorned the walls, a dark warmth permeated the space, and gold leaf and red-striped wainscoting surrounded the room. Other diners looked wealthy and conservative. When I met Deborah in that setting, I was awestruck—a leopard-skin jacket impressed me first, or was it the huge white-rimmed eyeglasses and leotards? Her hair was blondish—up and down, in and out, all askew. Large rings adorned her fingers, and long white fingernails matched her eyeglass frames. She, not I looked the artist. Our conversation was animated. We had so much in common, both in our personal lives and in our approach to work. It was a wonderful, exhilarating evening. ◆ Most of what I do expresses my feelings through colors and shape. As I worked I remembered the taste of that white chocolate crème brulée, felt it rolling across my tongue—so the shapes on the quilt undulate. The top is all one big painted canvas, except for the embroidered metallic touches, gold leaf, and appliquéd green-and-black-checked strips and blue satin ribbon, which are very rich and bold. Those elements are like the accent of spice in food. You don't need a whole lot; just a little makes it come to life. ◆ In addition to capturing my experience of Deborah's signature dessert, I've also tried to show the personal connection Deborah and I made. We are both strong, unique women with a vision. We have many life circumstances in common and support ourselves with our own businesses, which are also our passions. ◆ I did not have to create realistic images of food on my quilt after all. I know, as I'm sure Deborah does, that I must always be true to myself, which means doing what I do best. In this case, it was painting and quilting my experience at UpStairs at the Pudding, as guided by that voice within.

—ELIZABETH A. BUSCH

ELIZABETH A. BUSCH lives in Glenburn, Maine. She was educated in painting and art education at Rhode Island School of Design and worked as an architectural designer for twenty years. When her children were young she made stuffed animals and clothing, and began quiltmaking after they grew up because she still loved to sew. Although Elizabeth has been an artist all her life, she first began to support herself through her art (including sculpture) in 1987.

DEBORAH HUGHES is co-owner and chef of UpStairs at the Pudding, in Cambridge, Massachusetts. In the 1970s she began washing dishes at a communal Cambridge restaurant that valued all contributions equally. It was soon clear where Deborah's talent lay, and she moved into cooking, the first job that felt right to her. She opened UpStairs in 1982. Deborah loves the everyday theater of restaurants—like a production, each meal service has a beginning, a middle, and an end.

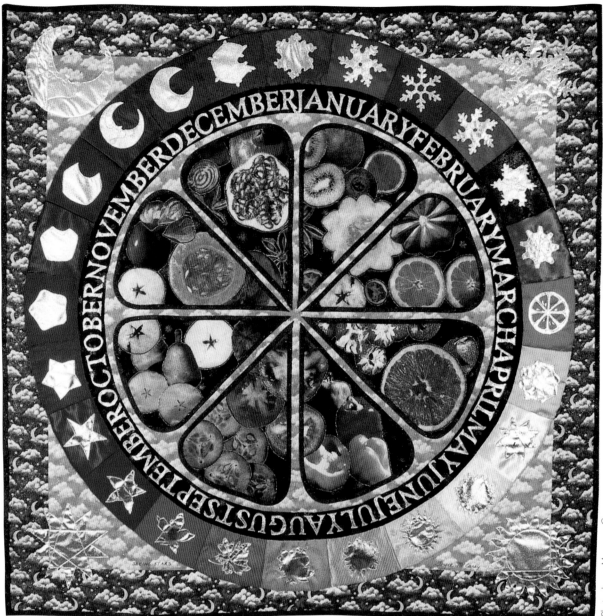

JOYCE MARQUESS CAREY ◆ ODESSA PIPER

SEEING STARS

51 x 51 inches

Cotton, silk, polyester, and lamé fabrics, and antique gold thread. Images photo-transferred. Machine appliquéd, hand and machine pieced, machine quilted, and hand embroidered.

The name of Odessa's restaurant is L'Etoile, "the star," and this quilt reflects Odessa's and my associations with stars and the seasons. Odessa sees the year in eight seasons of eating—late winter, early spring, early summer, high summer, autumn, harvest, solstice, and still point—and the segments of the quilt correspond to these. The design (computer-generated, to fit all the elements together properly) is also a star, like the segments of an orange. The month names, rainbow colors, and morphing from star to moon to snowflake to sun to leaf are further expressions of the seasons. The vegetables were transferred onto silk directly from my photographs (emphasizing star shapes), with gold thread handstitched around them.

24

dessa runs my favorite restaurant, L'Etoile. When we met, Odessa explained that the restaurant's name had evolved from her fascination with stars. She described a story she read as a child about a mythical maiden named Sophia, who, not comfortable in heaven with her brothers, came to hide on Earth in the shape of stars. Odessa sees stars throughout nature, especially in food, and thinks of them as the stars that came to Earth. "The stars we can eat are the stars that inspire our cooking!" says Odessa. ◆ Around 6:30 one October morning, I tagged along with Odessa and three of her employees on their trip to the farmer's market. Odessa had described her interest in sustainable agriculture and small farms, and I wanted to see just how a professional cook looks at food, as well as to take some photographs. Odessa is highly interactive with both vendors and shoppers. One of her first finds consisted of several enormous puffball mushrooms. She put them in one of her two Radio Flyer wagons and explained over and over to curious shoppers that the mushrooms were edible, talking through instructions for their succulent preparation. As we went along, she purchased heirloom apples, a great supply of elderberries, giant snow-white cauliflower, a jar of sorghum, edible flowers to garnish her dinner plates, tiny potatoes, tomatillos, baby eggplants, pattypan squash, and herbs. One vendor was offering all of his herbs at the same price per pound. She chose one—chervil, I think—and told the vendor that he should charge much more and paid him several times what he asked. By this time both Radio Flyers were full to overflowing, and her assistants wheeled them back to L'Etoile, which is right on the main square where the farmer's market is held—the dining room overlooks the market. She and I went on, gathering flowers and meeting her friends. When we returned to the restaurant, she gave me several items of produce to study and photograph. She later loaned me a book in which she keeps track of what produce is available in what weeks, which I used to compile a list of more "star foods"—Odessa particularly loves fennel and parsnip. Her book also helped me to place the produce within the quilt. ◆ I began photographing fruits and vegetables, some whole, some cut open to reveal the star shapes inside. Many are spectacular—the beauty-heart radish, for instance, and the pomegranate. I photographed squash, apples, pears, dill, eggplant, tomatoes, peppers, cucumbers, grapefruit, strawberries, ground cherries . . . it became an obsession. I came to look upon the fruits and vegetables as wonderful geodes, with amazing visual treasures inside which you could never guess from the outside.

—JOYCE MARQUESS CAREY

JOYCE MARQUESS CAREY lives in Madison, Wisconsin. She has sewed all her life, starting with clothing for her cat. She studied textile design in college and was a weaver for many years, and taught at the University of Wisconsin. In 1989, she left teaching to devote herself to artmaking fulltime. Many of her pieces are in public places, medical centers, and social-service agencies, where she hopes to make a positive impact on people's lives through her work.

ODESSA PIPER is owner and chef of L'Etoile, in Madison, Wisconsin. She grew up foraging for mushrooms and picking blueberries with her family, which impressed upon her the importance of good, local ingredients. In the late 1960s, Odessa joined a commune dedicated to sustainable farming and cooking only with what was seasonally available. In 1976, her excitement with the quality and diversity of the region's foods inspired her to open L'Etoile, whose name references the culinary mother tongue of her Midwestern interpretations.

RACHEL D. K. CLARK ◆ EMILY LUCHETTI

THE CHEF WORE CHOCOLATE

Irregular dimensions.
Cotton and blended fabrics, scraps from 1950s
tablecloths, chef jacket, beads, buttons,
and ribbons. Hand appliquéd, hand and machine
pieced, hand quilted, and hand embellished.

Emily is a dessert chef and I love most things chocolate—what a good match. I make clothing that draws from the rich heritage of my quilting background, so for this project I started with the foundation of a chef jacket. As I created quilt blocks with dessert-related names, such as Cake Stand, Cherries Jubilee, and Shoofly, I combined contemporary fabrics with dessert and fruit motifs with 1950s tablecloth scraps. I put banana splits on the sleeve. Finally, I coated the shoulders with a variety of brown fabrics so the jacket would have a dipped-in-chocolate look.

My sense of Emily came from conversations and from making desserts from her cookbook, duplicating the steps of her work. The recipes I prepared were pretty straightforward, just as Emily seemed to me. Like me, Emily takes her work seriously but has a sense of humor and knows that ultimately it's just food. That's how I feel when I create my clothing—I'm serious about it, and I want it to be expressive, but I know it's not a cure for cancer. My work is very important in my life, but I want to be able to laugh at it and make other people smile or laugh, to lighten someone's day. ◆ I do use my work to explore things that come up for me in terms of race and women, but not so much that you would spend hours analyzing it or having major discussions about how it will affect the world and change the social structure of black America. Every year for the Fourth of July, for instance, I make a watermelon outfit. For so many black Americans, the watermelon is a negative image. But how long do you allow yourself to be controlled by an image or a word? So instead I claimed the watermelon. I said, "This is a good fruit, a nutritious fruit, the colors are fantastic, and I'm going to have fun with it." ◆ I started out as a quilter, and I use traditional quilt blocks to help tell stories. A friend once told me that everything I make has a shaggy-dog story! It's true that sometimes the story is pretty thin—maybe just that I saw the fabric and loved it. In this case, I knew I wanted to give the jacket the feeling that it was dripping with chocolate. Once I know that first kernel of a story, I get excited and start looking for the right fabrics to help me tell it. ◆ I'm basically shy (though people always chuckle when I say this after they've met me). But I've found that one of the things that helps me deal with my shyness are my interesting garments. I keep most of the clothes I make and earn my living through teaching, so I have this huge closet of my own designs. When I'm wearing my outfits, people come up and talk to me, so I don't have to make an initial overture. We're all looking for an opening. I think we would all be a lot more comfortable, a lot happier with each other, and certainly more interested in each other if we all had these kinds of openings.

—R A C H E L D. K. C L A R K

RACHEL D. K. CLARK lives in Watsonville, California. All the women in her family, back to her great-great-grandmother, have sewed and quilted, and Rachel grew up sewing. Her only formal training came from a supportive high school home economics teacher. She began quilting while teaching home economics, as an arts-and-crafts project, and used it to meet people when she moved to Watsonville—her first time living away from a black community. When she combined quilting with making clothing, a lightbulb went on.

EMILY LUCHETTI is executive pastry chef at Farallon Restaurant, in San Francisco. Her family has always been interested in cooking, and her parents owned a cookware shop. After studying sociology in college, she realized that she could spend her life doing something she loved *and* get paid for it, and attended cooking school and apprenticed in France. She turned to desserts in 1987 while at Stars Restaurant, in San Francisco. She is the author of *Four-Star Desserts* and *Stars Desserts*.

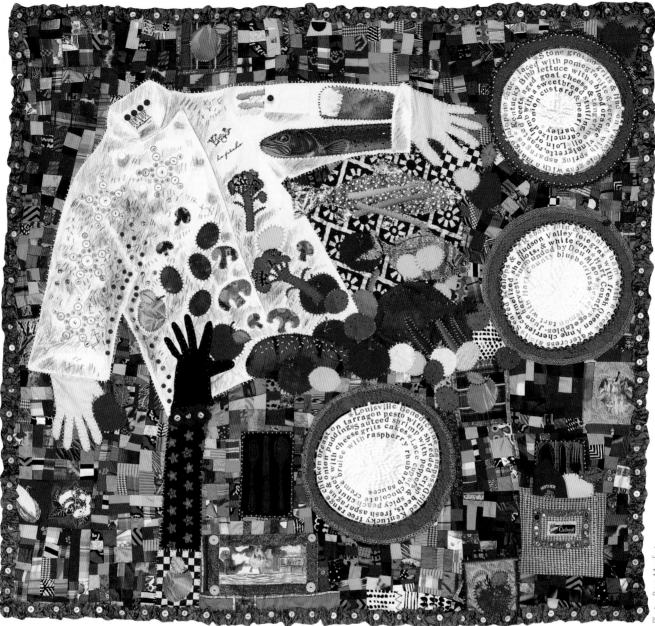

Photo: Pam Monfort

JANE BURCH COCHRAN ◆ KATHY CARY

BY THEIR HANDS

60 x 55 inches
Assorted fabrics, gloves, handkerchief,
Kathy's chef coat, pocket from Kathy's chef pants,
beads, and buttons. Images photo-transferred.
Hand drawn and rubber-stamped. Hand appliquéd
via bead application, machine pieced,
and hand tied via button application.

When I asked Kathy if I could illustrate any of her special dishes in fabric, she came up with a better suggestion—to depict her favorite ingredients. She also sent me her chef jacket and pants (I use clothing and found materials in all my quilts). Her menus read like poetry, so I stamped some of their text around the circular shapes, which represent dinner plates. Intrigued by her philosophies about food and by her involvement with her family, I echoed these relationships in the quilt. Kathy and I both love green and purple—she uses them in her restaurant's decor—so I incorporated them throughout the design.

For our first meeting, I invited Kathy to my house for lunch. I felt rather brave preparing food for a real chef, but of course Kathy was delightful and told me that she loves to entertain by cooking for her friends and family, which I found pretty amazing given how hard she works for her businesses. I asked Kathy about her evolution as a chef, and she told me that her earliest influences were her grandmother, Ida Maney Webb Thompson, and the African American woman, Lyda, who worked for her. Her first food memories are of sitting on her grandmother's floor and asking to eat the apple and peach peels while the two were cooking. She really learned to cook by watching Lyda—and only by observation, since Lyda didn't use recipes. As Kathy says, "The great cooks don't need the books." ◆ In 1979, Kathy opened La Pêche ("the peach"), her café, carryout, and catering business, and, in 1987, Lilly's, her restaurant, both in her hometown of Louisville. Kathy believes in using fresh, Kentucky-grown ingredients and has special relationships with many of the people who grow the produce she uses. She said, "I believe we are meant to enjoy the texture of life and reflect it in our work. While I love to travel and interpret other cuisines, in my own kitchen a small voice in my mind always says 'Remember your roots.' The very real things are close to home—the clarity of full flavors, ripe and fresh." After seeing my quilts, Kathy thought these were values she and I shared. ◆ In addition to celebrating Kathy's approach to food, I wanted to commemorate her as a wife and mother because the businesses are a real family affair—Lilly's is named after her daughter, and her husband serves as the restaurant's host and "Wine-Meister." I included a drawing by her son at the bottom center of the quilt, and, on the handkerchief in the pocket in the lower right, I photo-transferred images of her husband and their two children. ◆ When I brought the quilt to Kathy after finishing it, I had not yet determined its title—this is very unusual for me because the title almost always comes to me while I'm working, if not before I begin. Kathy suggested *By Their Hands*, which I think is perfect. My work often contains appliquéd gloves, which to me represent hands that reach and search for both questions and answers about race, the environment, the human psyche. Kathy says the title refers to the hands in the quilt, to the hands of those who grow and prepare the food she oversees, to her own hands, and to my hands, which made the quilt.

—JANE BURCH COCHRAN

JANE BURCH COCHRAN lives in Rabbit Hash, Kentucky. Her background is in painting and jewelry making, but she evolved into fiber arts because she loved holding and touching the materials. Her quilts combine the freedom of Abstract Expressionist painting with the time-consuming and controlled techniques of sewing and beading. Her work has its roots in Victorian crazy quilts and Native American beadwork, with a contemporary and narrative perspective.

KATHY CARY owns Lilly's, a restaurant, and La Pêche, a café, carryout, and catering business, in Louisville, Kentucky. After working in catering and restaurants in Washington, D.C., Kathy returned to Louisville. At twenty-two, she was the opening chef at a local restaurant, but soon left because she wanted to work for herself. She founded "From Seed to Table," a program to teach food growing and cooking to inner-city youth. Raised on a farm, she ends every menu with the words, "God bless our local farmers."

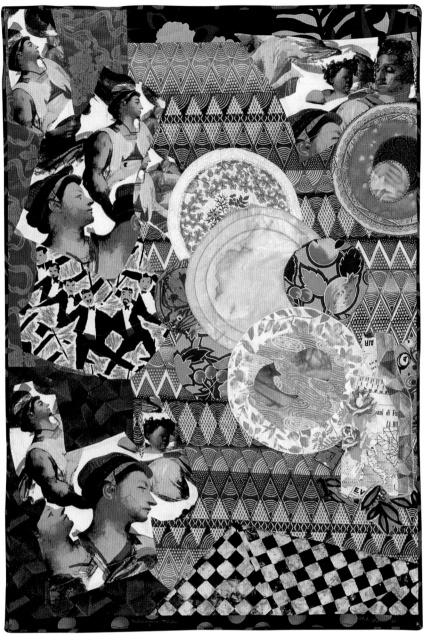

RHODA R. COHEN ◆ JOYCE GOLDSTEIN

MEDITERRANEAN KITCHEN

38 x 56 inches

Cotton, blends, and metallic fabrics, and rayon braid. Hand and machine appliquéd, machine pieced, and machine quilted.

Joyce and I discussed what it means when you say "Mediterranean cuisine," and she astounded me with its breadth, mentioning food from North Africa, Greece, Italy, southern France and Spain, and Portugal. Such a wide gamut of influences! I'm fortunate to have traveled to—and eaten in—most of the places Joyce mentioned. Through Joyce, I realized there were common elements among these cuisines, such as olive oil, tomatoes, pasta, fresh fish, lamb, citrus fruits, and wine. I said to myself, "It's going to be a tall order to show all of this—I'd better simplify it to the bare essentials," to communicate what to me is the essence of Mediterranean life.

Joyce and I live across the country from one another, so our collaboration consisted of conversations, correspondence, and cookbooks, as well as my memories of her restaurant, Square One. My daughter who lives in the San Francisco Bay Area visited Joyce and took photographs of her environment so I could learn a bit more. Joyce and I have traveled to the same places—we both love the Mediterranean. Both of us are collectors and have around us fabrics and all sorts of objects from the places we've traveled. Our objects enliven our surroundings without being too well-arranged. We are both devoted to building our personal libraries (Joyce has a library of three thousand cookbooks). The cookbooks she writes are very spirited and personal to Joyce—I feel I can hear her voice as I read them. ◆ As I set out to depict the Mediterranean, I hoped to distill the essence of my travel experiences, meshing what Joyce and I had discussed. I sought to sum up the feeling in just a few elements, which is harder to do, I think, than bringing everything in. I started with a fabric print with heads of Renaissance-looking people (very evocative of Mediterranean life), and fabric designed to look rather like North African tiling. I incorporated a variety of plates to suggest a diversity of tables from many countries. There are even singing waiters elbowing in. The ubiquitous wine bottle is included partly because wine is always part of Mediterranean cuisine and partly because Joyce's son, of whom she seems to be terrifically proud and with whom she works, is a noted wine expert. I wanted to communicate a sense of ethnicity without being over the top. Although I can get ethnic with the best of them, I wanted this quilt to be simple. To that end I created the quilt quickly, not allowing myself to dwell on the abundance of Mediterranean-type fabrics. The composition is united by vibrant, life-affirming colors. ◆ There is something totally compatible in pairing food preparation with patchwork. In both cases one needs to gather supplies and dedicate oneself to methods that will produce excellent results. Proportions of ingredients must be considered—Which will dominate? Which will accent? Just as there is room for great creativity in combining unusual flavors and textures of food, so is there the opportunity to combine terrific fabrics in deft configurations. And with both, the presentation is what really makes the finished product communicate.

—RHODA R. COHEN

RHODA R. COHEN lives in Maine, Massachusetts, and New Zealand. After taking a painting class in order to stay stimulated during her child-bearing years, she delved into the study of studio art and art history. Rhoda worked primarily as a painter until 1974, when she met quilter Nancy Halpern, who became her friend and teacher. She immediately gave up painting and took up quilting because she found the possibilities of expression through fabric inexhaustible.

JOYCE GOLDSTEIN lives in San Francisco. She has an MFA in painting from Yale, and was "reborn as a spiritual Italian" while living and eating in Italy in 1959. She had less time to paint when her children were born and turned to cooking. In 1965, she opened the California Street Cooking School. She closed her restaurant, Square One, in 1996 to "stop and smell the roses" as well as write, teach, and consult. Her most recent book is *Cucina Ebraica: Flavors of the Italian Jewish Kitchen.*

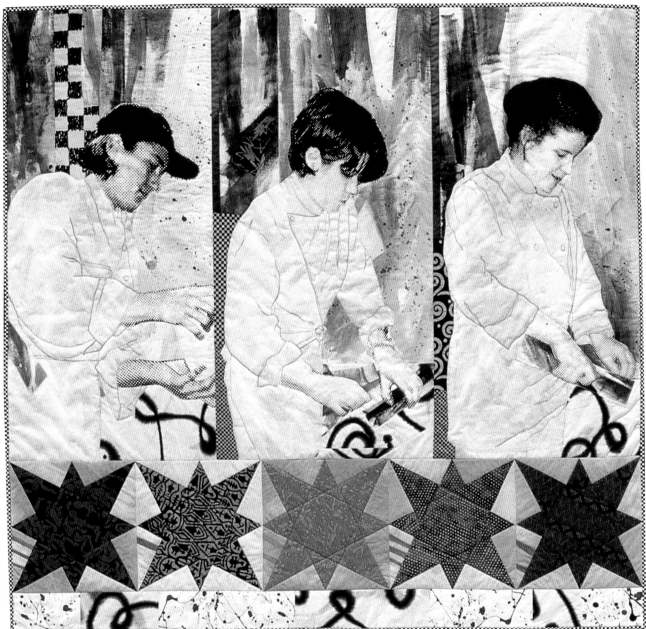

SANDI CUMMINGS ◆ MONIQUE ANDRÉE BARBEAU

SEATTLE ALL STARS

59 x 57 inches

Cotton fabrics. Hand dyed and hand painted. Photographs converted to halftones and screen printed. Machine appliquéd, machine pieced, machine quilted, and machine embroidered.

I visited Monique in her busy kitchen twice. The first time, one of the cooks called in sick, which meant Monique had to swing into action and help with the prep work. Since we couldn't talk, I spent time watching and taking pictures. It was an atmosphere of well-planned and -organized efficiency. The staff gave great attention to form and appearance. Each person knew exactly what he or she was supposed to be doing. The noise level was fairly high, but it was a mixture of chatter and work-related sounds. I decided I wanted my quilt to reflect the diligence and strength of the individual workers. The five stars at the bottom allude to the star ratings of restaurants.

When I began work on *Seattle All Stars*, I had some traditional star blocks on a working wall for a class sample, and it just struck me that the stars could tie in with the idea of a five-star restaurant. This quilt marked the first time I've explicitly combined the traditional with the contemporary, but since then I've done more of that. Even though this quilt is painted and has a contemporary look, you can still recognize the traditional quilt history. ◆ When I first started selling my quilts, ten years ago, the people who sold them felt they had to call them "fabric tapestries"— they felt no one in the corporate world would purchase a "quilt." The first piece sold immediately, and I was asked to do more. Every time I sent new pieces they sold. After the first few successes, I started calling them quilts on my invoice. With the evolution of art quilts, now corporations are specifically requesting quilts for their walls. My work sells primarily to hospitals, and I'm told that my pieces are favorites. I believe this isn't necessarily because they're so wonderful—obviously, they have to be liked, but I think the main reason is that people identify with fabric. This connection goes completely beyond my work. It's a carryover from our past, that we still like things to be made from fabric. I feel good that my work hangs in hospitals, where patients need to be comforted and soothed. ◆ The people who buy my work prefer contemporary, original designs. I also occasionally enjoy working with traditional blocks in a non-traditional style. Because the format is already set and I don't have to make certain kinds of decisions— instead, it's an exercise in color. I find this very relaxing. When I design something from scratch, something completely different, *that* is work. I enjoy alternating between the two, because they're totally different activities for me and nurture my creativity in complementary ways. ◆ It's meaningful to me that quiltmaking is a women's heritage and that I am part of that group of artists who express themselves with original designs in cloth and thread. For me, quilts represent the quiet strength of women and the caring side of humanity. They represent the persistence of women in bringing beauty to the home, family, and to our everyday lives. In keeping with that spirit, I want my work to be affirmative, and to reflect vitality and strength.

— SANDI CUMMINGS

SANDI CUMMINGS lives in Moraga, California. She studied political science, but after college traveled and dabbled in stained glass, pottery, batik, macrame, painting, and jewelry making. Though she didn't like to sew when she first learned how, in home economics, when she found quilting, she knew it was her medium. After she'd made a few pieces, she marched into a bank and said, "How would you like to hang some quilts?" and her career was launched. Sandi has even inspired her mother to start quilting.

MONIQUE ANDRÉE BARBEAU is executive chef of Fuller's Restaurant, in Seattle. Raised in Vancouver, she studied at the Culinary Institute of America because she wanted to see another part of the world. After graduation she cooked at several New York City restaurants, and also earned a degree in hospitality management. She travels around the world for new ideas and says her cuisine is "globally influenced and regionally inspired."

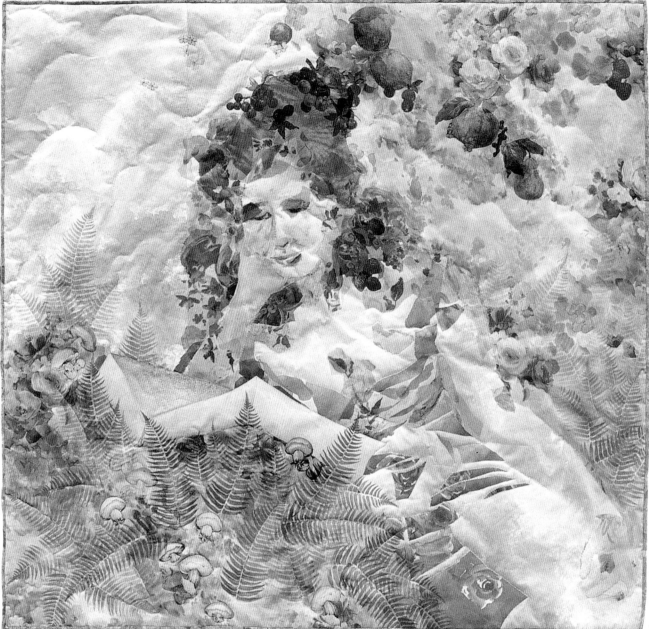

DEANNA M. DAVIS ◆ FRANCES WILSON

WOMAN DREAMING

60 x 56 inches

Cotton, silk, and polyester fabrics.

Hand stenciled with oilsticks.

Hand and machine appliquéd, machine pieced,

and hand and machine quilted.

Frances and I met both at her "California fresh" gem of a neighborhood restaurant and at her home. I was struck by so many things—how well-liked she is at the restaurant, how she uses all her senses with food, and how she works by hand and not by spoon. I thought of many questions to ask her, and as we talked, associations came to mind. Relying on my sense of her and on photographs, I worked with fabric and an image grew steadily—a sweet, strong face emerged to talk to me on our journey.

After agreeing to this project I struggled with second thoughts and great fears. Because I usually create a piece by letting the work speak to me and direct its course, I worried knowing that someone else would be involved in the quilt's design. I felt that I hadn't yet identified the issue or vision to explore, and wondered about how I would portray someone else's message. However, the most wonderful thing happened when I met Frances! Her serenity and warmth comforted me and I felt absolutely empowered, nourished, and calmed by her manner. I immediately began to muse. ◆ After our lunch at her restaurant, I drew a simple circle chart with Frances' name in the middle, free-associating her qualities: curved shapes (not angular), California fresh, intuitive, sumptuous, nurturing, hands in food, Botticelli, sylphids, greens for Ireland, red-gold hair, presentation importance, the influence of Japan, complexity of tastes, plants and trees (interesting, because most people talk about flowers), gardener, family tradition, sweetness of face, Madonna images, not intense, cookbook collection, likes words but doesn't write them, pitcher collector. ◆ I very much wanted to see her home, the second story of an old farmhouse, so our next meeting took place there. We conversed about gardening, and she told me that she feels close ties to her mother when she gardens. We talked of cooking and families and womanly things. And all the while, I sat there bewitched by her strawberry golden curls floating in the rare winter sunlight, the feminine essence and godliness of her. I took several photographs. ◆ I often thought of calling Frances and asking her to come visit my studio as I worked, but by now she was very busy. The creative process was problematic. I was using techniques that I had only recently developed, and these unknowns caused me many anxious moments. But I wrote "Trust must be here" in my journal, and my quilt image kept talking to me. The womanly figure spoke of nourishment and comfort, wisdom and peace. ◆ Real words about the quilt were very slow to come to me. They always are. The quilt was completely finished before I opened a magazine and saw the right phrase: "In oneself lies the whole world, and if you know how to look and learn, then the door is there and the key is in your hand" (J. Krishnamurti). It has been a wonderful journey that Frances has taken me on. I regret that she wasn't present in my studio while I worked, but in a way, she was. Thank you, Frances.

—DEANNA M. DAVIS

DEANNA M. DAVIS lives in Piedmont, California. She studied art, worked as a nurse, and later found her voice in quiltmaking during a family crisis. Intensely involved in quilt design for ten years, she has learned by experimentation and from workshops and local classes. Her greatest satisfaction comes from works that explore emotionally charged issues because they provide a reflective time to gain understanding and to solve problems.

FRANCES WILSON is chef of Lalime's, a quilt-adorned restaurant in Berkeley, California. She taught home economics, physics, and Gaelic in Dublin before studying cooking at the Dublin College of Catering. On what was intended to be a short break from teaching, Frances moved to Berkeley in 1990, lured by its reputation for good food. She soon began a new career at Lalime's. In her cooking, she is committed to sustainable agriculture and seasonal foods.

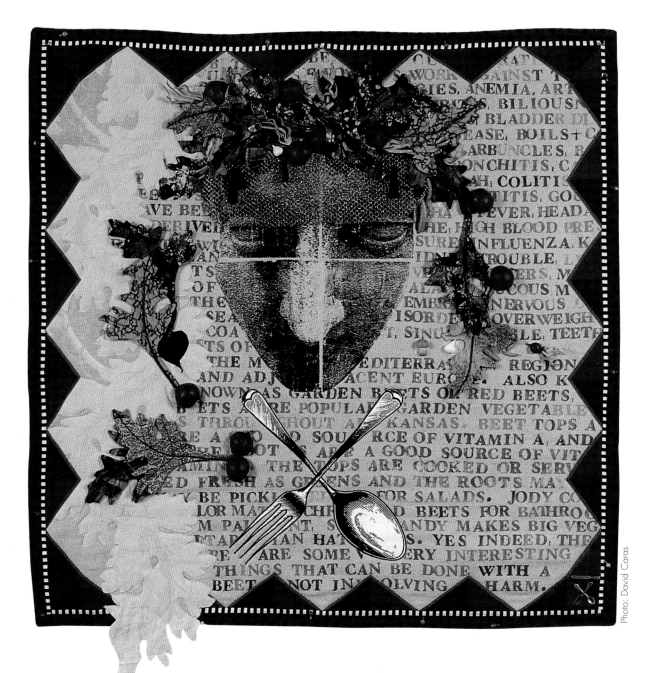

Photo: David Caras

SANDRA TOWNSEND DONABED • JODY ADAMS

INTERESTING THINGS
YOU CAN DO WITH BEETS

54 x 58 inches

Linen and cotton fabrics, plastic vegetables, stuffed fabric leaves, glitter, metal charms, papier-mâché ornaments, and metal netting. Hand drawn, rubber-stamped, and hand painted. Images photo-transferred. Hand and machine appliquéd, machine pieced, and machine quilted.

As I got to know Jody and her restaurant, the following events conspired to cinch the beet theme: first of all, I learned that she'd brought a beet to the paint store to match her bathroom color; next, over time I collected *several* beet recipes she'd concocted, with one appearing in the newspaper *while* I was deciding the quilt; then, I sampled her beet appetizer at Rialto; I saw her prepare a beet dish on a Christmas special; and finally, I happen to love beets, both the way they look and the way they taste.

All of my quilts are autobiographical—my husband says it's because no one can read my handwriting, and perhaps he's right. Luckily the quilting stitch is more forgiving. Each piece is based on an event, a place, an emotion, a memory, a moment in time that touches me in some way, or, as of now, a vegetable. ◆ I prefer working with free-form shapes, which I cut without templates and then appliqué. My approach is similar to collage: I build layer upon layer, moving things around in a more painterly fashion than one can do with pieced work. I cannot remember making most of my pieces when I am done—the memory of the actual physical part of the surrealist technique of assembly is gone, almost like automatic writing, where one allows the unconscious mind to take over. ◆ I like to work with vintage and found fabrics. For this quilt Jody gave me an assortment of treats, of which I used some material hand painted with fava beans, snipped from a chef coat from her previous restaurant. The background fabric, leftovers from linen slipcovers, I found in Florida, provided a great foundation for the photo-transfer face because the texture showed through. At the flea market I found an apron that had a very large spoon and fork printed on it. The red harlequin border is leftover expensive linen decorator fabric from a drapery border. Everything was available when I needed it! ◆ From my research, I found that beets are used for curative purposes for a long list of diseases, and I incorporated some text about that into the background. The final stage in all of my quilts is what I call the "frosting"—when I add three-dimensional elements to the surface. I never have a plan before I begin. Shopping at Wal-mart, I came across plastic vegetables, including some fabulous beets—though I ended up having to go to two more Wal-marts to supply myself with enough beets. Then Wendy Huhn visited, and I nearly passed out when I learned that her subject was beets also! We went shopping together for beet-colored beads the very next day. In a hardware store I found a roll of gutter guard—this, with the addition of glue and bronzed glitter, became the veil on the vegetarian hat. The tassels and passementerie came directly from my living room— I figure when the quilt comes back from its tour, maybe my tastes will have changed!

— SANDRA TOWNSEND DONABED

SANDRA TOWNSEND DONABED lives in Wellesley, Massachusetts. She has degrees in education and design. In her first quilting class, she was forced to endlessly take apart and restitch Log Cabins, and vowed never to quilt that way again. Until she was in her forties, she had trouble accepting that art and sewing could coexist. A workshop she teaches titled "Diversions of a Quiltmaker, or Real Artists Don't Do Housework" promotes the prioritization of artmaking over domestic duties.

JODY ADAMS is chef and partner of Rialto, in Cambridge, Massachusetts. Her passion for food began at her family's dinner table and during childhood travels in Europe. In college, she worked for Nancy Verde Barr, the food writer and teacher, and discovered she was happier studying cooking than anthropology. In Boston, she worked at various restaurants before opening Rialto, where her seasonal menus are inspired by the regional cuisine of the sun-drenched Latin crescent—France, Italy, and Spain.

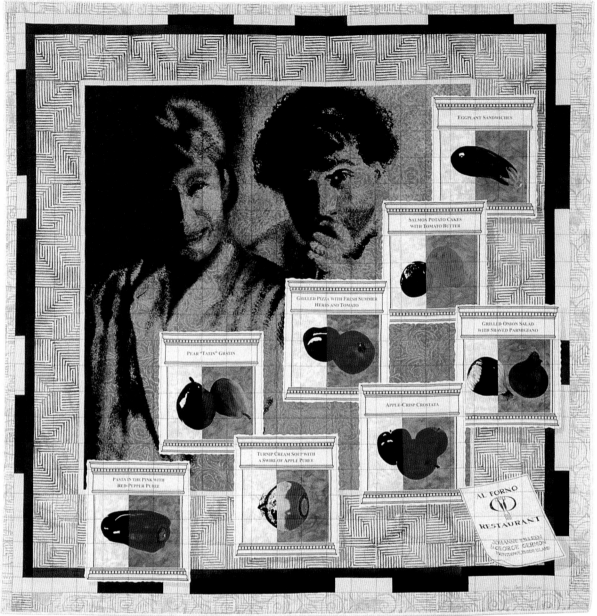

Photo: Jon Blumb

CHRIS WOLF EDMONDS ◆ JOHANNE KILLEEN

AL FORNO

58 x 58 inches

White cotton printcloth. Hand printed with hand-carved wood blocks and hand painted. Text generated by computer. Machine appliquéd, machine pieced, and machine quilted.

Distance and busy schedules prevented Johanne and me from enjoying a close working relationship, but Johanne sent me a copy of *Cucina Simpatica*, the cookbook she'd written with her husband and partner, George Germon. I don't love to cook—I work better with fabric and paint and words. But I do appreciate the effort and creativity of good cooks, and Johanne and George's words made this collaboration possible. Each of the produce elements represented in the quilt design is a title ingredient in a recipe from a different chapter. The photograph of Johanne and George appears on the book's dust jacket, and the base and border fabrics are painted and printed to evoke the personality of their restaurant.

TURNIP CREAM SOUP WITH A SWIRL OF APPLE PUREE

Normally when I begin a new piece, I gather research notes and photographs I've taken, design and carve wooden blocks for printing, and start mixing paint. This time, I read a cookbook filled not only with wonderful-sounding recipes but also with photographs of food, Johanne, her husband, their staff, and their restaurant, Al Forno, itself. Then I made a trip to the market to gather fruits and vegetables featured in Johanne's recipes, considering variety, color, and form, rather than ripeness, quality, or quantity. ◆ In my studio, I prepared the white cotton printcloth which forms the starting ingredient of all my quilts, then I painted the fruit, vegetables, and backgrounds for the individual recipe patches. The base and border fabrics were sponge-painted and then printed with wood blocks carved in designs meant to echo the spirit of Al Forno as I perceived it via *Cucina Simpatica*. For the central panel, I painted the light-and-shadow image of Johanne and George from their dust-jacket photo (by Linda Megathlin). The recipe borders and titles (generated on my computer, and printed on prepainted fabric) contain just enough information to make your mouth water. Once I created all the panels, I appliquéd them into place. ◆ Working with the fruits and vegetables wasn't so far from my usual work, for my primary inspiration is life in all its forms. As an artist and amateur naturalist, I collect the colors and patterns of the world around me and attempt to preserve them in my hand-painted and -printed fabrics for quilt designs as well as in my wood sculptures and handmade books. I spend part of every day outdoors observing the comings and goings of life in nature. I am fascinated by the relationships between colors and by the magical way they are affected by light, atmosphere, and time. In my search for inspiration and meaning, I am always looking for connections—to the other creatures who share our world, to the past, to my own immediate history, to the history of human discovery, and to our prehistory as glimpsed through the artwork our ancient ancestors left us to represent the world of their experience. I feel it is my responsibility as an artist to record and preserve the colors and patterns of the Earth, in order to appreciate my value in its evolution and to enjoy my moment in time. Perhaps my work will serve as some small memento of this moment for future generations, who, I can only hope, will be searching for their own connections.

—CHRIS WOLF EDMONDS

CHRIS WOLF EDMONDS lives in Lawrence, Kansas. A fifth-generation Kansan, she comes from a long line of needle artists and other creative folks. She grew up sewing, and also painting, printing, and crafting in wood. It wasn't until she began designing quilts that she realized art could be her vocation as well as her lifelong avocation, and she left behind the "practical" career for which she'd been educated.

JOHANNE KILLEEN is chef and co-owner of Al Forno, in Providence, Rhode Island, and Café Louis, in Boston. While studying photography at Rhode Island School of Design, she spent a year in Italy. Inspired, she began experimenting with Northern Italian cuisine, and in 1980 she and her husband opened Al Forno, serving only lunch so they would have their afternoons free to make art. The restaurant soon became a full-time passion.

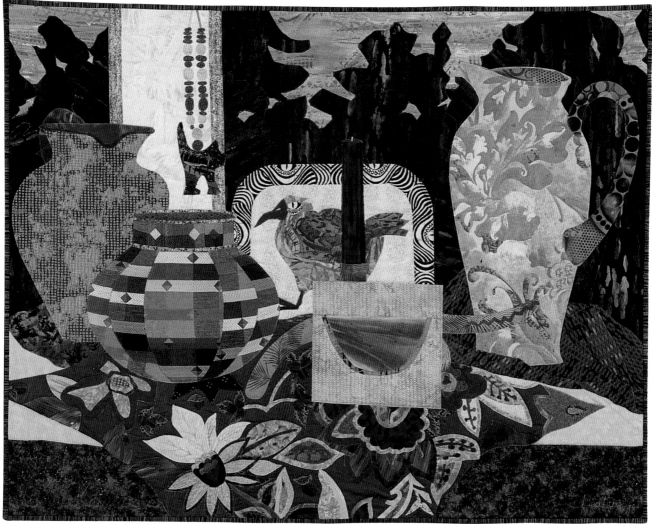

BEATRIZ GRAYSON ◆ MOLLIE KATZEN

**VARIATIONS ON A THEME
BY MOLLIE KATZEN**

60 x 48 inches
Cotton fabrics. Machine appliquéd, machine
pieced, and machine quilted.

Through conversations and letters, I found that Mollie shares my love of fabric, and I love vegetarian cooking, so I felt we were kindred spirits. Because we both have tight schedules and live on opposite coasts, I thought our collaboration might consist of my interpreting, in the quilt medium, one of Mollie's book illustrations—she liked the idea. When I asked her to select a favorite, she said she could not choose among her "children," so I picked an illustration from her newest book, *Vegetable Heaven*. I took some liberties but mostly followed her lead. It was exciting to see how fabric added texture to the flatter rendition one gets with pastels or oilsticks.

Dear Mollie,

You have been, through your books, part of my life in a major way as I go through life collecting teachers. I haven't made a dish following your recipes that I didn't like. ◆ Last spring, independent of this project, I was asking myself, "What do I get from using fabric that I don't get from using paints? Why do I like working with fabric?" I knew the answer right away. It is the sensual quality of touch, combined with the challenge of using the found object, of doing something novel with a particular print. This all became very clear after I took reproductions of works by some of my favorite painters—Amadeo Modigliani, Milton Avery, Louisa Matthiasdottir, and others—and made collage variations in fabric. In each case I felt I added to the meaning of the painting by using printed fabric. I use existing fabrics exclusively, and to me the quilting medium is a metaphor for making the best of life and the cards one is dealt. I must admit that when I have a particularly hard time finding the right material, however, I find myself jealous of those who dye and paint their fabrics. ◆ I think this Women of Taste piece should have content that is simple yet interesting, should be visually delicious, colorful without being garish, and should have elegance of forms indicating quality without being ostentatious. Do you have a favorite from *Still Life with Menu*, or new stuff from *Vegetable Heaven?*

—BEATRIZ GRAYSON, *excerpts from a letter to Mollie Katzen*

This process was more like parallel play than collaboration. I gave up some autonomy in the design but regained it in the execution, and because I also make original pieces, I don't worry about my creative juices. Variations on other artists' work is one thing among many that I like to do. I think of it as playing jazz—it is a matter of emphasis on the syllable. Mollie's illustration has a lot of yellow, mine more blue. Her still-life objects are highly polished and transparent, while mine are more textured, more matte, heavier. Reworking someone else's theme is a matter of syncopation—how a melody flows or how an eye moves within a composition, be it musical or visual.

—BEATRIZ GRAYSON

BEATRIZ GRAYSON lives in Winchester, Massachusetts, and is originally from Brazil. She studied art in Brazil and New York and has a master's degree in special education. She has worked as a designer of interiors, products, and architectural graphics, and taught art at the elementary level to special-needs students. Her love for textiles and sewing started in the atelier of her dressmaker mother, but it wasn't until her mother was ill and needed cheering up that she made her first quilt.

MOLLIE KATZEN lives in Berkeley, California. She has degrees in music and painting, and did not taste a fresh green vegetable until the age of twelve. She is a founding member of the Moosewood Restaurant, in Ithaca, New York, and a pioneer in vegetarian cuisine. At the request of Moosewood customers, in 1977 she compiled her first cookbook, drawing from her illustrated food journals. She has continued to write and illustrate cookbooks, and has hosted two television cooking shows.

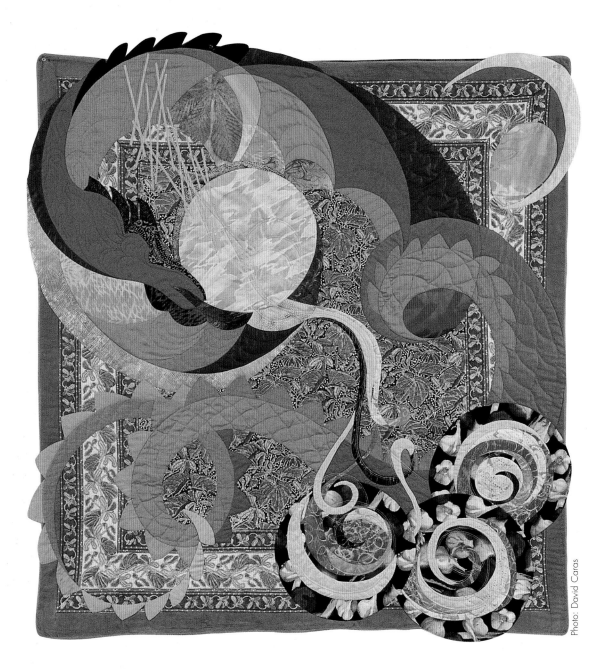

NANCY HALPERN ◆ CRESCENT DRAGONWAGON

GARLIC SPAGHETTI

54 x 58 inches

Various fabrics, including old tablecloth, pantsuit, yard-sale curtain, and furniture upholstery. Hand dyed and hand printed. Hand appliquéd, machine pieced, hand and machine quilted, and hand embroidered.

My first thought was that Crescent could be represented by one of my favorite recipes, "Chicken Nouveau'zarks," from her *Dairy Hollow House Cookbook*. But Crescent sweetly demurred, as she's a vegetarian, and asked if she could be a dragon—"of course!" On went the lightbulb over my head. Crescent's garlic spaghetti provided food inspiration—I dyed special "spaghetti fabric" and included the handwritten recipe on the back of the quilt. *Garlic Spaghetti* bears almost no resemblance to my usually straight-edged work. Its curves evolve directly from the subject matter—some spaghetti and garlic, the pot, egg, crescent, and dragon. Curves of learning, too! Also, it's a quilt about circles of friendship, as represented by the bowls of spaghetti on the bottom right.

JULY 25. Dear Crescent, Perhaps you as the dragon could be blowing on the flames under the spaghetti pot, or materializing out of the steam from the spaghetti (or both). I'll do some research on dragons. I am enclosing the fabric for you to handwrite the recipe on. ◈ AUGUST 20. Dear Nancy, Here is the fabric Garlic Spaghetti scroll. I *love* the idea of the dragon blowing on the flames under the pasta pot. Perfecto. I will draw you a couple of dragonwagons—the kind I used to quick-sketch in lieu of signatures. I do not see them as those elaborate, scary, Chinese-looking ones, but more plump and lizardy, with iridescent scales, major attitude, low threshold for pompous or stupid behavior, a tendency toward crankiness at times, high self-esteem, the occasional moment of unpremeditated sweetness—kind of like the personality of my cat, come to think of it. I realize I have just expressed more psychological than physical traits, but you can interpret through that dream-time filter all artists use. ◈ SEPTEMBER 20. Dear Crescent, I am truly grateful for your hands-on involvement as well as philosphical counseling on dragons and garlic spaghetti. Here are some other dragons I've found. I know that the first is too gothic, the Chinese one too ferocious (but how about those shaggy bangs?), and there's many a slip between the New Age and the kitsch. But Crescent! Your dragons lack wings! What with your slowly mending broken leg, this summer seems to have been a bad time for dragons' legs and feet, and it seems to me that backup wings are a good idea. Besides, they are artistically interesting. How about wheels on your back legs and claws or your arms, which could be sieving the spaghetti into bowls? And do I know how I'm going to construct this curving, swirling quilt? Definitely not yet! ◈ OCTOBER 1. Dear Nancy, Wings for a dragon / Would not be lagging / Yes that is certainly clear / Far from my bragging / My leg still is dragging / Wings would be handy, my dear. I like the direction you're headed. Here's another dragon—yes, this fellow (a distant cousin) is a bit hirsute and fierce, though we're always polite at family gatherings. ◈ MARCH 5. Dear Crescent, I hope your leg is entirely mended, and that spring has returned to your step as well as the weather. I now have a design (enclosed), a goodly chunk cut out (but not sewed), and a healthy respect for dragons. ◈ MARCH 14. Dear Nancy, Well, my dear, what can I say—MAGNIFICENT!! You have managed to combine dragons, garlic, et al., so artfully that I know this quilt will be an absolute socks-knocker-offer. I'm in awe!

—NANCY HALPERN and
CRESCENT DRAGONWAGON, *correspondence*

NANCY HALPERN lives in Natick, Massachusetts. She has studied English and architecture. She began quilting in traditional patterns but when she couldn't find one she liked that she hadn't already made, she turned to designing her own, drawing inspiration from nature and architecture. She is especially interested in color and fabric dyeing. Because she likes to work slowly, she stopped selling quilts and now parts with them only as gifts.

CRESCENT DRAGONWAGON lives in Eureka Springs, Arkansas. She moved to the Ozarks from her native New York City in 1972. She began writing professionally in 1969, publishing countless articles, poems, children's books, and cookbooks. From 1981 to 1988, she and her husband, the writer Ned Shank, owned and ran Dairy Hollow House, a country inn. In 1999, they helped found the nonprofit Writers' Colony at Dairy Hollow, which offers residency fellowships for working writers.

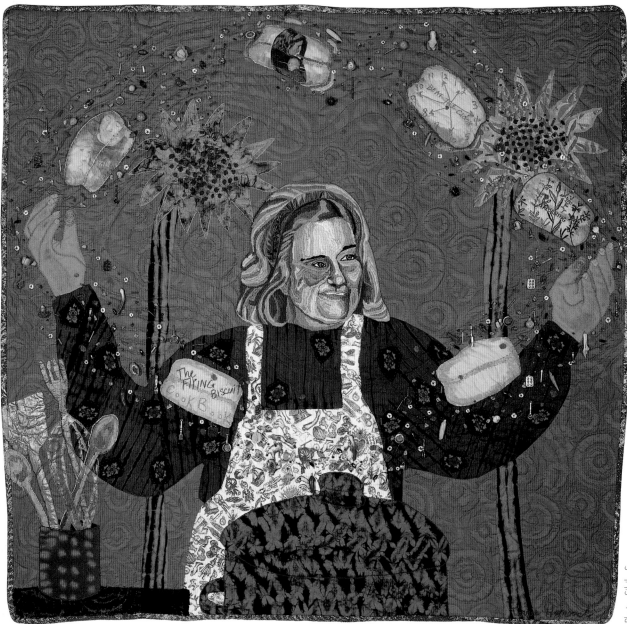

Photo: Sibila Savage

TERRIE HANCOCK ◆ APRIL MOON

APRIL MOON'S FLYING BISCUITS

48 x 48 inches

Cotton fabrics, beads, and charms.
Screen printed, hand drawn with colored pencil,
and painted. Images photo-transferred.
Hand appliquéd, hand embroidered, and hand
embellished. Hand quilted by Sue Rule.

When I met with April, she told me that the main thing she struggled with was juggling the different elements and personas in her life—I could definitely relate to that. She works in a restaurant, the Flying Biscuit Café, where most of the other women are lesbians, while she has a husband and children. At the time, she was trying to write her cookbook, take care of her kids, spend time with her husband, and fulfill her professional duties. So that's what made me think of picturing April juggling her flying biscuits, each with a different reference to her life, including photos of her husband and kids, a clock, and plants to represent the healthy, reasonably priced food April makes.

have so little time to make quilts that it was very important to do something that resonated within me. I don't eat meat, only fish, and am an environmentalist, so I wasn't interested in doing something about a big T-bone steak or rack of lamb. I love all those pastry paintings by Wayne Thiebaud, but I really wanted to focus on healthy food. It was a conflict for me whether to work with a pastry chef, because my whole family is overweight and I have worked hard to maintain a healthy body. I first thought that if I did a pastry quilt, I would have to show this obese person gorging out, with sugar coursing through the bloodstream and fat accumulating everywhere. But I thought a chef might not like that, and I really wanted to work on a piece that was positive, about something I really believed in. Although I sometimes feel as if I am being difficult, I realize that my beliefs and definite preferences are why I do strong work. ◆ When I heard of April Moon, my first thought was that her interesting name alone could inspire a quilt without further ado. I visited her restaurant, in Atlanta, for Saturday breakfast. People were lined up out the door, and the place was so inviting, very arty and colorful. I felt it was a perfect match. We met briefly and made plans to go to her house the next day. When we discussed our lives, I realized that the main challenge we each faced was juggling our work, our families, and the demands of society. April's ideas about cooking have to do with comfort and nutrition, much like mine. She strives to make organic, good-quality food accessible to the middle-income person, and she succeeds in this at the Flying Biscuit. ◆ A few years back I started doing portraits—my quilts have usually been narrative, and when you're doing narration you end up talking about people. In this vein, I decided to portray April, using solid embroidery for her face, a technique I borrow from Native American women in the Oaxaca area of Mexico (I have traveled quite a bit, and am influenced by traditional needlework from all over the world). The embellishments floating all around the biscuits are vegetables and other healthy items. ◆ Like April with her food, I would like to serve up affordable art for the masses One way I've tried is by designing a line of fabric. Maybe I'll do a book, too, as April has. Both of us like to do it all.

—TERRIE HANCOCK

TERRIE HANCOCK lives in Valdez, New Mexico. She always had a knack for sewing, and started to teach herself after asking for fabric as a Christmas present when she was five years old. By the time she was a teenager, she did all the mending for her family of eight. She majored in printmaking and ceramics but gravitated to quilting in 1978. She has owned a bead and fabric store, and her paintings and drawings have been reproduced in a commercial textile line.

APRIL MOON is chef of the Flying Biscuit Café, in Stone Mountain, Georgia. She wasn't sure what she wanted to do when she started college, so her mother advised her to cook because she enjoyed it. She apprenticed and studied in Atlanta, San Francisco, and at the Culinary Institute of America, and took over the Flying Biscuit in 1993. She is the author of *The Flying Biscuit Café Cookbook*, featuring her "signature healthy comfort food." As a child, she did not like biscuits.

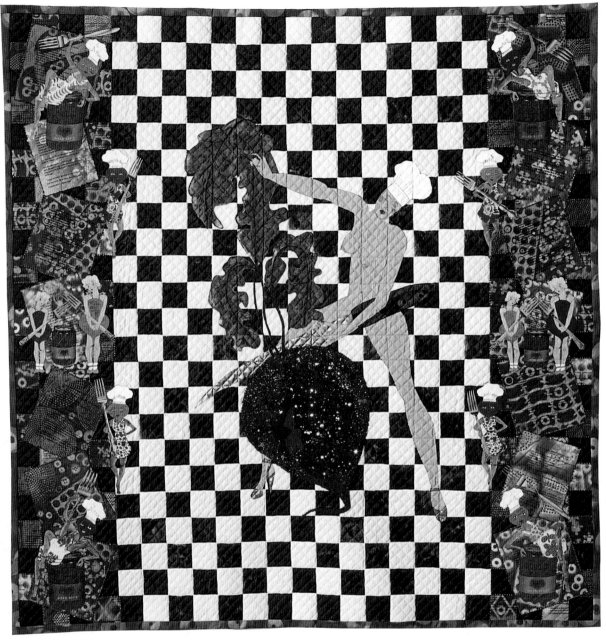

Photo: David Loveall Photography, Inc.

WENDY C. HUHN ◆ AMEY SHAW

BEETS-BEETS-BEETS!

48 x 48 inches

Cotton and cotton canvas fabrics, including cotton from the 1940s, and beads and sequins. Screen printed and heliographically printed, and hand painted and stenciled. Images photo- and gel-transferred. Hand appliquéd, machine pieced, machine quilted, and hand embellished.

I wrote Amey an introductory letter, asking her many questions, such as, "If you were a vegetable, what kind would you be?" After Amey relayed to me her life story, I had a vision of foods floating around, carried by women chefs wearing only hats. She sent me menus from her restaurant, and I first heard about her famous salad, "Beets, Beets, and More Beets." I assigned some Bay Area friends to a secret restaurant reconnaissance mission, and they raved about the beets—"Man, was that a fabulous salad"—and took a picture for me before they gobbled it down. Amey then sent me the recipe, which I screened onto the heliographic fabric on the sides.

My imagery is heavily influenced by magazines from the 1920s through the 1950s, which I collect. The titles of the articles and ads are often inspiration for a piece. I keep notes and sort images from the magazines into files. As I begin to work I pull the journals and the files—organized according to categories like appliances, shoes, or bras. Then I photocopy the images, reducing and enlarging as needed. I pin these black-and-white xeroxes to a wall, and when I'm happy with the arrangement I decide what techniques and colors are appropriate. ◆ As a child, I was constantly cutting images from magazines and reassembling the pieces to create my own paper dolls, and that remains my life's work and passion. Imagery is the force motivating me to make art. My quilts are my way of telling stories visually, as words do not come easily. Inspiration comes to me through the everyday situations I find my friends and myself engaged in—relationships, the meaning of life, and trying to make sense of it all are the "food" for my work at this stage of the game. While I continue to deal with images based on gender issues—especially women's place in American society—I attempt to do so with a whimsical, tongue-in-cheek style that transforms the ordinary into the extraordinary. ◆ The beet goes on.

—WENDY C. HUHN

I started cooking with my friend Caron when we were about eight years old. Our claim to fame was Spaghetti-O omelets—actually, they were more like fritattas and not too bad. After studying journalism I moved to Berkeley and thought I would get a job at a newspaper, but that didn't work out and one thing led to another—roofing, house painting, community organizing. Finally I accepted a job as a cook at Pizza Hut, and was surprised to realize how much I loved it. Oh, not the $3.99 per hour, but the actual work. I could not afford to stay on, so I went back to community organizing and bartending, and slowly realized that I loved food above all. I would find myself in bookstores reading over cookbooks—I thought everyone did that. One day, I had a realization. I was sitting in my miserably cold Berkeley flat, and suddenly it occurred to me that the mysterious spice in the pinto beans last night had been—cumin! It was as if a light had reached out from the heavens, tapped me on the head, and said "Hey, maybe you are a cook!"

—AMEY SHAW, *letter to Wendy C. Huhn*

WENDY C. HUHN lives in Dexter, Oregon. Her background is in whitewater rafting and fibers. After she turned from tapestry weaving and basketry to fabric, the first art quilt she entered in a show was returned with the comment, "Seams should be cut to 1/8 inch." Her mother is amazed that she makes a living in the textile arts because she once made a three-sleeved shirt in home economics. She describes herself as "a serious artist with a sense of humor."

AMEY SHAW is chef and co-owner of the Alta Plaza Restaurant and Bar, in San Francisco. She has been cooking in the Bay Area for twenty years. After realizing she wanted to be a cook, she began paying her dues by going to cooking school, then by scrubbing walk-in refrigerators on her hands and knees. A few jobs and glass ceilings later, she became executive chef at the Fourth Street Grill, in Berkeley. "I had arrived," says Amey.

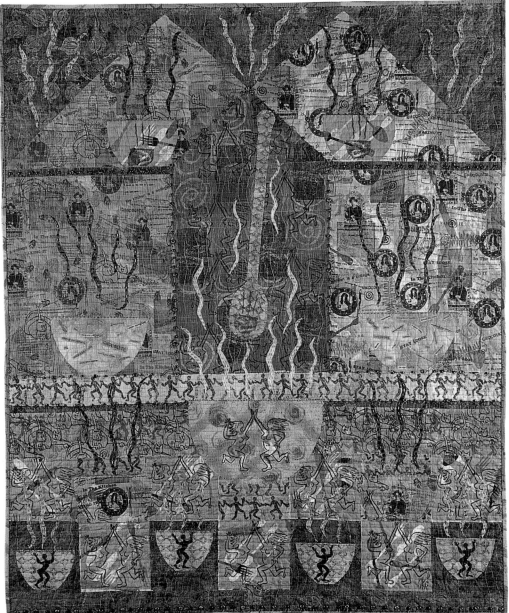

NATASHA KEMPERS-CULLEN ◆ ALICE MAY BROCK

COLLAGE SOUP

62 x 51 inches
Cotton and vintage linen fabric painted with
fiber-reactive dyes and textile inks,
and tulle, glass beads, and rayon thread.
Images screen and block printed.
Collage constructed, machine stitched
and quilted, and hand embellished.

Collage Soup is the playful, delightful outcome of a yearlong collaboration between myself and Alice. We met for a weekend at her Cape Cod home and talked and talked, discovering many similar interests and proclivities. The next step was for us to meet in my studio, in Maine, and spend a weekend creating images (Alice illustrates books). We agreed on a selection and then I printed them onto panels of fabric. At the end of our weekend, the studio walls were filled with several energetic, colorful paintings. After about two months of "stewing" time, I reached for my scissors and started collaging away.

When I was invited to participate in this project, I jokingly declared, "Wouldn't it be fun to work with a legendary figure—say, Alice of Alice's Restaurant?" Lynn Richards, whose baby this whole project is, said "Why don't you see if you can track her down?" I didn't think that was even within the realm of possibility, but as these things sometimes go, through a series of seemingly unrelated events, I did indeed find Alice, and then I knew this collaboration was meant to be. It was a thrill to discover how funny, talented, hard-working, and creative Alice is. I was not experienced at working so closely with another person, so it was quite an adventure for us both! ◆ During our two fabulous brainstorming and arts-and-crafts weekends, we focused on various themes: the meeting of two women in midlife, our discovering similar interests, our mutual love for our cats, and the fact that we both work in a collage-like manner—Alice with her cooking, and me with my visual artwork. The overlapping house shapes represent our meeting each other and joining forces to create. There are bowls of steaming soup throughout the work. Cats in a row watch contentedly as two women (that would be Alice and me!) dance rather wildly around the quilt. A great big ladle is suspended over the central soup bowl, ready for stirring. Words and phrases from Alice's early cookbooks and from an article I wrote emphasize many of our like-minded approaches to creativity, and photographs of the two of us complete the portrait. Alice said that our collaborative process was like watching "patterns in nature—as our words and emblems were repeated and multiplied, they revealed themselves as parts of a bigger picture." To make that bigger picture into an actual quilt, I applied my "collage construction" technique—I cut and move pieces of fabric until I'm satisfied with the composition, lay tulle on top of the whole thing, pin it into place, then ever so carefully machine-quilt an allover grid to stabilize the design. ◆ Three themes that appear in all my work are here as well: a reverence for nature, a positive human spirit, and the concept of house and home as safety and love and strength. The title, *Collage Soup*, is based on my motto, "More is better." The creation of a soup is like making a collage—a little of this, some of that, this item first, then that one . . . leave it alone for a while, then add more of this. And so it grows and becomes rich. This has been such a positive, educational, exciting, and truly collaborative adventure! What's next?

—NATASHA KEMPERS-CULLEN

NATASHA KEMPERS-CULLEN lives in Topsham, Maine. She studied studio art in college, and has taken many courses in fiber art. She taught art in the public schools for sixteen years. Since then she has been making art quilts and teaching workshops full time. She has not used commercial fabrics in many years, preferring instead to paint, print, and dye with many different techniques. References to traditional quiltmaking appear in her work to honor the women and the history of the medium.

ALICE MAY BROCK is an author and illustrator in Provincetown, Massachusetts. She got into trouble as a girl and was sent away from her food-loving family to reform school, where she was encouraged in her artwork. After college, political activism, and cooking at home for students such as Arlo Guthrie, she opened Alice's Restaurant at the urging of her mother and husband. It took her twenty years to realize that just because you're good at something doesn't mean it's good for you. She has written or illustrated four books.

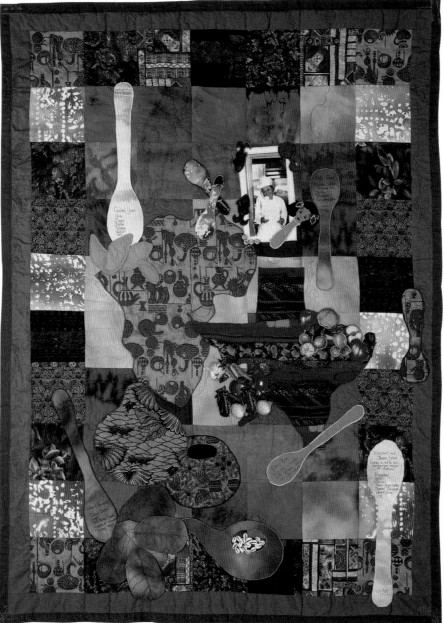

Photo: Sibila Savage

ANITA HOLMAN KNOX ◆ CASSONDRA G. ARMSTRONG

A TRADITION: PASSING IT ON

56 x 76 inches

Cotton fabrics and cowry shells. Hand dyed, inscribed, and painted. Machine appliquéd, machine pieced, machine quilted, and hand embellished.

"I know this great chef," a friend said to me when I told her of this project, and so I met Cassondra. As we got to know one another, Cassondra explained that her interest in cooking began as a young child while she watched her grandmother and mother in the kitchen. The image she associates with her mother is the spoon, which triggered many ideas for us and became a focal point in the quilt's design. I incorporated foods we both like and wrote recipes on the spoons. I needed a picture of Cassondra on the quilt, so there she is at the upper right, wearing a chef hat.

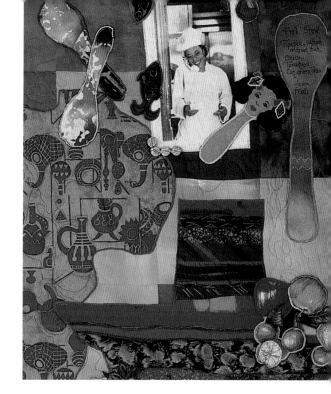

Cassondra and I had a great time talking about recipes and foods. We especially looked at African American and African dishes, and at foods you find in Texas and Oklahoma, where I'm from. Both Cassondra and I grew up cooking with our families. My mother and aunt are excellent cooks, and on holidays the whole family gets together for big meals. They've been doing twenty-five-person Christmas dinners since 1945, and now I've taken over Father's Day. These traditions are all interrelated, especially in the staples we love to eat, such as sweet potatoes, collard greens, and rice, all of which I pictured on the quilt (the rice is represented by the cowry shells). Cassondra is very health-conscious and works to adapt these traditional dishes so they don't have as much sugar or fat. ◆ Both quilting and cooking are communal—sharing recipes, and patterns, and fabrics, and ideas—so the spoon image resonated with me. The spoon is used to blend ingredients and is also a metaphor of blending cultures, especially as it relates to cooking. We have embraced a taste of Africa through our foods and many of those written and unwritten recipes are a part of African American food traditions. ◆ Usually my quilts include both abstract and realistic elements. I have a personal iconography that comes through whether I'm painting, designing stained glass, or dyeing fabrics and making quilts. For example, I love gourds, so I included them in the quilt. Gourds are used in Africa and other world cultures as containers, to hold grain, water, or milk, and also as instruments and decorative objects. I'm big on color, and I like experimenting with different combinations and dyeing techniques to design and color my own fabrics. I like to mix the traditional with the contemporary because I love both—I don't think you have to choose one or the other. In this quilt, there's a more traditional grid underlying the free-form curvier pieces. ◆ Though I initially thought of quiltmaking as a way to develop my own designs in a quilted format, I began to understand the rich history and traditions involved in making quilts. It is a tradition that combines African weaving and sewing and dyeing with European quilting. It crosses ethnic and cultural boundaries to become a celebratory gift of love for families and individuals worldwide. Women have always been the ones to pull things together, whether with the spoon or the needle. For me, quilting has become not just a means to an end (the finished quilt), but an extension of the ties that bind us as families and link us together through tradition, culture, and ethnicity.

—ANITA HOLMAN KNOX

ANITA HOLMAN KNOX lives in Fort Worth, Texas. She earned a BFA from Howard University and an MFA in fiber and surface design. She has worked in many media, but primarily painted until she took a basic quilting class around 1980. That class and an elderly quilter neighbor inspired Anita to combine traditional quilting with her painterly skills. She also curates, creates community murals, and teaches drawing and painting at a local junior college.

CASSONDRA G. ARMSTRONG owns Dining Table Catering and Restaurant, in Dallas. Though she studied business and public administration in college, she assisted her mother in catering for seventeen years and ultimately decided to pursue food service full time. She opened Dining Table Catering in 1985, returned to school for a degree in food and hospitality, and in 1991 used her life savings to open Dining Table Restaurant. She promotes healthy cooking through the American Heart Association.

Photo: Susan Webb Lee

SUSAN WEBB LEE ◆ ALISON NEGRIN

SALAD PLATES

50 x 50 inches

Cotton fabrics.

Hand dyed, painted, and drawn.

Commercial prints.

Machine pieced and machine

and hand quilted.

Because color has always been my primary motivation for making art, and Alison told me that colors are very important to her in the process of working with food, I wanted to use some colors she liked. The bright reds, red-oranges, golden yellows, and purples (as in radicchio, according to Alison) are among Alison's favorites. Everything in the quilt is artfully arranged on bluish Japanese platters in unusual shapes, on a table covered with a tablecloth that could be black-and-white *ikat* fabric. These Japanese influences were also cued by Alison—she has traveled extensively in Asia, studied Japanese, and was a private chef to a Japanese billionaire.

had not heard of Alison before this project, but through long-distance telephone conversations I learned quite a bit about her experiences with food. She also described her art studies (she continues to practice photography) and time spent in Asia. She comments, "I was an artist but couldn't earn a living as one so I became a chef. Sixteen years later, cooking has become my art medium. I love its intricacies, its detail, and its flexibility; it's a medium that continues to grow as I age." Alison's cooking specialty is the combination of unusual ethnic culinary tastes: she often prepares dishes that feature such diverse combinations as Mexican and Thai elements. She likes variety and unexpected arrangements of tastes. I asked Alison about her preferences in fabrics, and she told me she loves natural fibers, especially cotton, and finds textural fabrics very appealing. ◈ Alison's young son is a major influence on her life, and she described how having a child has changed her method of working—among other shifts, she's given up a "glamorous" way of cooking. I thought that she and her son might draw on fabric, since children are usually so uninhibited in their artwork, and made some suggestions to go along with the fabric I sent: perhaps large or small patterns, stripes, letters, numbers, her name, a recipe, dots. She and her son performed their magic on the fabric and returned it to me. ◈ I thought a lot about trying to make this a food-related quilt, and decided to use a variety of greens to represent lettuce, spinach, asparagus, English peas, and so on. The reds spotted with gold seem to have a definite tomato quality about them, as does the red fabric with black circles—it could be watermelon. And then there are many slices of eggplant, cooked, of course, but not peeled. ◈ I began this quilt with no preconceived idea as to how it would look when finished. My work has moved from predominantly rigid, geometric surfaces toward more emotional, painterly constructions. My quilts are always unplanned in the beginning, and I work in a rather deliberately unstructured way. I enjoy the freedom of not being restricted by a preplanned design, and of allowing the process of quiltmaking to become more spontaneous—I describe it as "intuitive piecing." Everything here, from the food to the platters to the tablecloth, is open to interpretation, and nothing is too literal. *Salad Plates* is something to be seen and enjoyed, savored as a gourmet dinner.

— SUSAN WEBB LEE

SUSAN WEBB LEE lives in Weddington, North Carolina. She has degrees in commercial art and art education, and started quilting in 1979, when she took a course in surface design. She wound up with lots of dyed fabric that needed a purpose, and began making quilts from single pieces of fabric. Over the years she has expanded into piecing, painting, appliqué, beading, and embroidery, and also continues to dye and paint many of the fabrics for her quilts.

ALISON NEGRIN is chef and partner of Poulet, in Berkeley, California. She began working in the culinary arts to earn money while studying at the University of California, Berkeley, as a fine-arts major. What had been make-do work caught her interest, and she decided to study cooking at the California Culinary Academy. She has worked at East Bay restaurants including Chez Panisse, and in 1997 joined Poulet, a gourmet takeout and catering business.

SARAH LEVERETT & PATRICIA CURTAN ◆ ALICE L. WATERS

ALICE'S GARDEN

54 x 54 inches

Cotton fabrics. Images drawn, cut on linoleum

blocks, and printed on an antique letterpress.

Hand pieced and hand tied.

Alice, Patricia, and I have been friends since 1973. Pat has cooked at Chez Panisse and designs and illustrates cookbooks with Alice. We share an appreciation for community and things made with care by hand. We decided to make a quilt with Pat's beautiful linoleum-cut illustrations of fruits and vegetables. I selected the fabric for its quality— hand-dyed and all-natural—and rich, earthy colors, which I associate with Alice. Pat printed the center squares and the border in her studio, and I stitched them into Log Cabins and assembled the quilt. Pat and I tied the quilt with the help of my friend Jeanne.

I am not a quilt artist, but an ordinary person who makes quilts which are not particularly original but useful and beautiful in their very small way. They are the result of time spent thinking about someone, a gift of love, an expression of a relationship, but not artwork—more like a meal fixed at home for friends, or a tin of cookies, than like a meal prepared by someone like Alice. ◆ I am a lawyer by trade, and in my spare time, in addition to making my own quilts, I organize non-quilters to create quilts in commemoration of births, birthdays, and weddings. A group of Alice's friends made a quilt in honor of the birth of Alice's daughter, and we have made other quilts in the Chez Panisse community. When I collaborate with non-quilters, I give them a dimension and, if they don't sew, let them know there are so many other things they can do—draw, glue, photocopy. It is amazing to see what everybody comes up with. I also belong to a quilting group that has met weekly for over twenty years to make quilts for the members' loved ones. ◆ The quilts I make are mostly about the person for whom they are intended. I choose the colors, design, and approach with that person in mind rather than illustrating a thing or expressing an abstract concept. As Pat and I discussed our ideas, Pat said, "Pure and simple, that's Alice," and this thought guided our design. This was the first quilt I'd ever made that was not meant as a gift for a specific person. I found that difficult, so I made the quilt for Alice and Pat. When the quilt returns from its travels, it will belong to them. ◆ When you make something by hand, it takes time, and during that time you can be really present with what you're doing. Inspired by Alice, those in the Chez Panisse community share the belief that if you start with good basic materials and pay attention to creating with your hands, the finished object will have a special quality. *Alice's Garden* reflects that approach and embodies Alice's commitment to fresh, organically grown food prepared carefully and shared by friends.

—SARAH LEVERETT

SARAH LEVERETT is a family lawyer and mediator living in Oakland, California. She has made special-occasion quilts for many family members and friends and has a goal to make a quilt for each one. Her quilts are made to be used. She comes from a family of quilters and has quilts made by both grandmothers and a great-grandmother.

PATRICIA CURTAN is an artist and designer living in Napa, California. She combines her interest in food, cooking, organic gardening, and art and printing in her work rendering images of plants in the linoleum-block medium.

ALICE L. WATERS is the internationally renowned founder of Chez Panisse, in Berkeley, California, and a pioneer of the movement toward fresh, local, seasonal, and organic foods. She is the author of five cookbooks and is engaged in many philanthropic efforts to educate people about the relationship of food to both agriculture and culture.

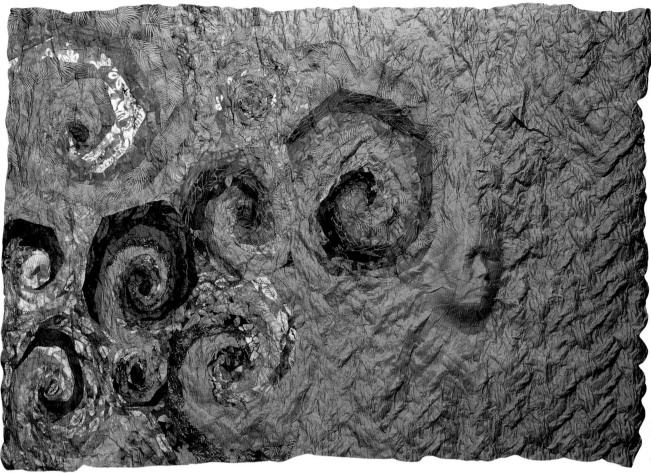

Photo: Sibila Savage

KARIN LUSNAK ◆ JENNIFER TEOH

NYONYA

61 x 42 inches

Cotton and silk fabrics. Shapes embossed over molds with fabric stiffener. Hand and machine pieced and hand quilted.

Through my conversations with Jennifer, I began to see parallels in our seemingly dissimilar lives. Although Jennifer was born in Penang and grew up in Kuala Lumpur, in Malaysia, and I am from Pennsylvania, we are both part of large, extended families and now, due to unexpected circumstances, both live far away from most of those people. The layered, swirling forms of the quilt are meant to suggest Jennifer's history—parents and grandparents, the country and city where she grew up, the people she has known, the important events, all the things that coalesce to shape a life. Jennifer's likeness emerges from the quilt, embossed on a mold I cast of her face.

Jennifer learned to cook at her mother's side in Kuala Lumpur, and it was her description of the food she cooks that lured me into our collaboration. She calls it "Nyonya," a style of cooking that embraces the best of Chinese, Indonesian, Malaysian, and Indian ingredients and methods. She uses hot chiles, garlic, shrimp paste, shallots, lemon grass, and other ingredients and spices indigenous to Southeast Asia. This happy union of cuisines is one offspring of the marriages between wealthy Chinese traders of the Straits and Malay women, whose daughters were known as *nyonya*, and sons as *babas*. ◆ Jennifer's immigration to the United States was unexpected. She came for a visit with her parents so they could celebrate their fiftieth anniversary with a daughter who had moved here, but during their stay her father fell ill. Jennifer stayed behind to help her sister pay the subsequent hospital bills. "Now I'm here," Jennifer told me. ◆ I asked Jennifer how she began catering, and she said, "You know, I give lots of parties. People say you should be a caterer. They ask me to cook for them. That's how I started." From a small kitchen, Jennifer can cater events for hundreds of guests, working with three chefs and six to nine helpers. She is extremely well organized and energetic, though she says she always leaves some things to the last minute in order to achieve a "sense of the natural." She is one of nine children, and employs a niece and a sister as well as a nephew whom she is training to carry on the business. She is rooted in a strong, supportive family tradition—Jennifer mentioned to me that Teoh is her maiden name, because when she married, her father said to her husband, "My daughter is married to you, not sold to you." ◆ As I meditated on my conversations with Jennifer, I was reminded of a previous work of mine, *Modern Maypole*. In that piece I used the strands of a maypole as symbols representing the environmental, familial, and spiritual experiences that affect our lives. Here too is the embossed impression of the maypole, suggesting the weave of life and symbolically representing my own history as a weaver and textile artist and now a partner in the creation of this quilt. Layering of physical form and metaphorical content allows me to suggest that life is influenced, changed, and directed by family members, fellow workers, and events over which we have no control. A path is at the same time created and delimited. As individuals, we interact with this environment of people, place, and time to create our lives and leave the imprint of our spirits.

—KARIN LUSNAK

KARIN LUSNAK lives in Albany, California. She studied biology as an undergraduate and worked for over twenty years as a research associate in genetics and molecular biology, but has continuously pursued her interest in various textile art forms since 1976, when she discovered the Pacific Basin School of Textile Arts. In 1994 she earned her MFA in textiles from the California College of Arts and Crafts. She works with materials that convey a sense of movement and time to express her view of life as a journey. She uses fiber, an essentially pliable element, in ways that suggest both solidity and strength.

JENNIFER TEOH is chef and owner of a catering company, A Taste of Malaysia, in San Pablo, California. She immigrated to the United States from Malaysia in 1978. She uses fresh ingredients to prepare authentic Nyonya dishes for businesses and individuals.

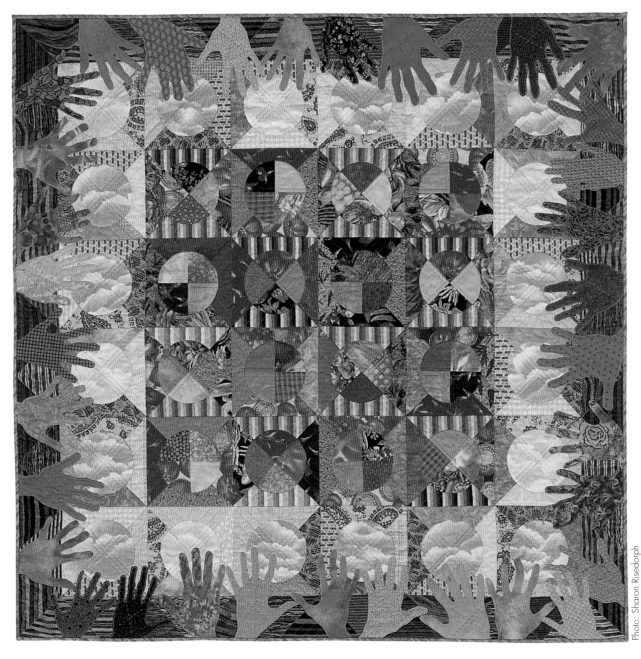

Photo: Sharon Risedorph

MARY MASHUTA ◆ ANNIE SOMERVILLE

MIXED GREENS

57 x 57 inches

Cotton fabrics. Machine appliquéd,
machine pieced, hand stitched,
and machine quilted.

When I met Annie, she told me about her background and time spent at the Zen Center's Green Gulch Farm in Marin County, California. She also gave me a copy of her cookbook, *Fields of Greens*. After I prepared several delicious recipes, I realized why it was so wonderful to have the trained Greens crew create my meals at the restaurant— I would rather be an eater than a fixer. Many of my quilts are story quilts, pieces that somehow relate to an experience of mine, to something I was particularly thinking about while creating the quilt. It dawned on me that this quilt should celebrate my dining experiences at Greens.

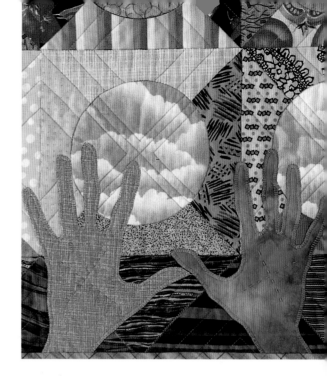

Greens Restaurant is located at Fort Mason, in San Francisco, a unique location in a former army supply facility and now a national park in an urban setting. It has spectacular views of the San Francisco Marina and the Golden Gate Bridge. Every year, Fort Mason hosts a big craft fair put on by the American Craft Council, so one of the times I find myself at Greens is during the fair, with friends—a wonderful combination of associations. As I spoke to Annie and explored the restaurant, I realized that the concept I needed to incorporate into the quilt, with Annie's input, was how I related to the Greens environment. ◆ Greens was founded by the Zen Center, and Annie is one of the only people left at the restaurant who associates with the center and with the Zen faith. She has an inner peaceful glow to her—you get the feeling that she really lives her religion. I'm sure that quality relates to how she works with the Greens employees, who seem to truly enjoy their jobs, no matter what their duties or positions. Annie says the customers can feel that camaraderie, and that "food is what brings us all together." ◆ To personalize the quilt and celebrate the staff that prepares the delicious meals, I asked Annie to collect hand tracings of as many Greens' employees as she could. I cut the hands from green fabric and machine-appliquéd them to the border of the quilt. My hand and Annie's appear at the bottom center. As I stitched, I thought of the hands that did the work—each had its own personality and was beautiful in its own way, whatever its size or shape. ◆ So much of Greens depends on what you see out the window, this glorious land- and seascape. I love the Bay Area, especially the wonderful food, and when I return from somewhere else and see "San Francisco" flash on the roadsigns, I always feel a surge of pride. Greens is one of the places that to me is San Francisco. No matter the weather, it is always a good day when I eat at Greens. ◆ The outer border of blocks, featuring cloud fabrics surrounded by yellows and golds, represents the spectacular view at Greens as well as two prominent cloud paintings inside the room. For the central area of the quilt, I used a simple, repeated circle-in-a-square block that I varied with fabric choice. I recycled some vegetable prints and striped fabrics that had been cut, but not used, in another quilt. As Annie has said, "You don't always have to start from scratch."

—MARY MASHUTA

MARY MASHUTA lives in Berkeley, California. She has two degrees in home economics and has worked as a teacher. In the early 1970s, she and her sister stumbled upon a quilting class and knew they had to take it—though later they found out that the teacher was only a week ahead of the students. Both Mary and her sister went on to become full-time quilters. Mary has written three books, and bills herself as "the foremost buyer of striped fabric in the United States."

ANNIE SOMERVILLE is executive chef of the Zen Center–owned restaurant Greens, in San Francisco. Trained by founding chef Deborah Madison, Annie has been with the vegetarian restaurant since 1981. Since taking over the kitchen in 1985, Annie has continued to use fresh vegetables and inspiration from the Zen Center's organic farm, Green Gulch, to create flavors and presentations that are clear, simple, and light. She is the author of *Fields of Greens*.

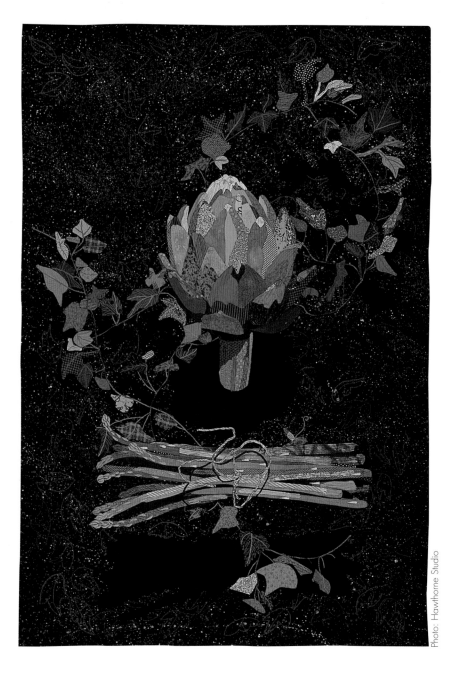

Photo: Hawthorne Studio

KATIE PASQUINI MASOPUST ◆ DEBORAH MADISON

ARTICHOKE, ASPARAGUS, SIDE OF IVY

38 x 54 inches
Cotton, blended, Ultrasuede, and lamé fabrics.
Machine appliquéd and machine quilted.

I didn't recognize Deborah's name before we started our collaboration, but when I asked which cookbooks she'd written, I realized that two of her books, *The Greens Cookbook* and *The Savory Way*, are the *only* ones I unpacked for use during a long-term house-building project! We met at her house, looked through photos, and decided on an artichoke theme. We met again to photograph artichokes sent from California, but the in-a-bowl composition turned out to be too busy and uninteresting. I then worked with my photographer to set up a still life—and added some asparagus and ivy—using a strong light to create deep shadows that make everything appear to float. I worked quickly on my own and Deborah loved it.

60

Since childhood I have been painting and expressing myself in the visual arts. I began quilting in 1978, and my quiltmaking experience has been an exciting journey through different techniques and styles. My earliest quilts were very geometric. I began making traditional quilts, and evolved into mandala designs. After discovering a book on three-dimensional design, I created dimensional quilts. A book on isometric perspective led to several years of crafting fantasy quilts based on isometric design. ◆ In 1994, I moved to New Mexico with my family. The landscapes were so beautiful that I was inspired to take a photography class to help me with my quiltmaking. I started exploring the countryside with my camera, because you can't take the countryside home to study it. At one point, I was enjoying the photography so much that I thought, "Maybe I should just give up quilting and become a full-time photographer," but then regained my senses and realized I could keep putting the two together. Now all my quilts are based on photographs. In comparison with quilting, photography gives such immediate satisfaction, but I find it fun to try to take a great picture that's worth interpreting into a quilt. ◆ Given that we weren't creating a landscape, it was a departure from my current quilting work to collaborate with Deborah. I was thrilled with the match because Deborah's cooking philosophies are so close to my own, and also because she turned out to be so great herself! The only element of the quilt that Deborah was clear on as we began was the artichoke. She suggested that we set up a still life with asparagus and sweet peas, but there were no sweet peas available when I began to photograph, and I felt it was important—and consistent with the way Deborah cooks—to use something that was actually in season at the time. Instead, I chose ivy. I placed the asparagus underneath the artichoke because the stalks lent themselves so well to a horizontal orientation and provided some grounding for the composition. ◆ Working from the photograph, I began to make the actual quilt. I used the same sort of appliqué techniques as I do with my landscapes, but with a much more detailed approach. In contrast with the sweep of a landscape, it was refreshing to focus on the vegetables, to pay attention to all the little color variations—much more than you'd imagine without looking so closely—and make them look as real as possible without being too cartoony.

—KATIE PASQUINI MASOPUST

KATIE PASQUINI MASOPUST lives in Santa Fe, New Mexico. She was a painter before she started quilting in 1978. As a painter, she used a palette knife and oil paint and enjoyed the textural aspect of the medium. She now achieves that texture with fabrics and feels she's painting landscapes with cloth, a full-circle return to her painting roots. She has authored five books, each on the quilting style she was working in at the time.

DEBORAH MADISON is an author and teacher living in Santa Fe, New Mexico. As a child she was intrigued by good food and would cut school, ride her bike three miles home, and make a soufflé just to see if she could do it. She cooked at the San Francisco Zen Center in the 1970s, then at Chez Panisse until 1979, when she left to help open Greens Restaurant, in San Francisco. Her most recent cookbook is *Vegetarian Cooking for Everyone*.

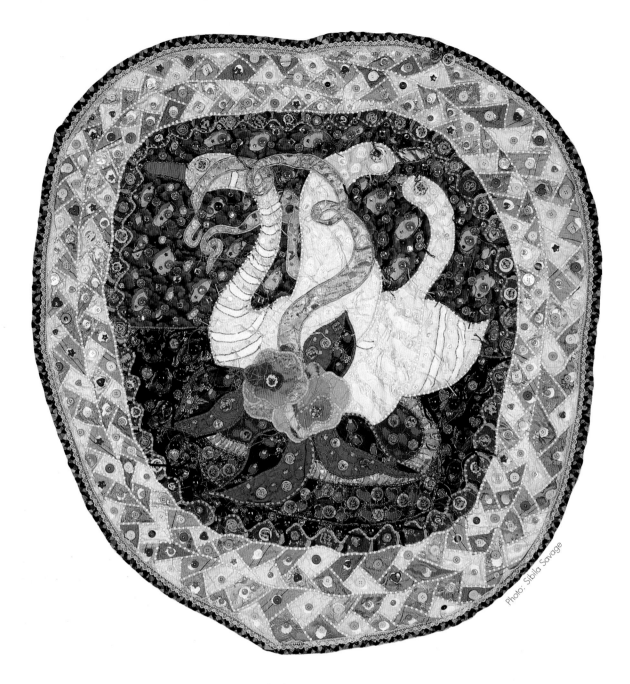

Photo: Sibila Savage

THERESE MAY ◆ LOAN CO

SWANS

47 x 50 inches

Cotton, silk, and satin wedding-dress fabrics, lace, buttons, novelty threads, handmade Fimo buttons, beads, and hand-braided cloth border. Hand painted. Machine appliquéd, hand quilted via embellishments, and hand tied.

Drawing inspiration from photographs Loan sent me of her spun-sugar wedding-cake sculptures, I chose three swans decorated with ribbons and flowers as my quilt's subject matter. I sketched directly from that single image and then took it from there, letting the piece evolve into my own creation. I wanted to convey the feeling of a wedding, and made the quilt into somewhat of a heart shape. I used wedding-dress fabrics for the swans, with novelty thread to make it shimmer a bit. Then I put it together and embellished it. Because the adornment process brings the quilt to its conclusion, it is always a celebration, different each time and yet the same.

When I found out that Loan makes wedding cakes, I thought, "Boy, I would love to make a quilt depicting a cake with lots of wonderful decoration, colors, fancy swirls, flowers, and ribbon forms." The idea, I mused, would really fit with my style of work because I use so many buttons, beads, and paint dots and dashes that can look just like frosting. But that was before I saw the photographs Loan sent me. Her creations are not your traditional wedding cakes, all embellished and decorated, but are instead much more subtle and quiet and simplified, with fabulous spun-sugar candy sculptures—very beautiful. ◆ I have always thought of chefs as artists, but the more I looked at the photos of Loan's work the more I realized that she is an artist in every sense of the word. At one point, Loan mentioned that she was getting ready to go to a trade show in New York and was preparing some of her sugar pieces for shipping to the show. It felt very similar to the way I so often get my quilts ready to ship off to exhibitions. ◆ I got in touch with the busyness of Loan's life, to which I could certainly relate. I was very intrigued and impressed with what Loan produced and with the skills that she has spent much time learning. When I see the colors and forms and designs she comes up with, I am amazed at the complexity of these beautiful objects which she creates to be seen for such a short time and then consumed, never to be appreciated again except in photographs and memories. Loan told me, "I enjoy making wedding cakes because they celebrate an important time in a woman's life." ◆ As I made the quilt, the swans reminded me of beauty and grace—and also of the story of the ugly duckling who just didn't fit in and was feeling so upset and then finally discovered that it had grown and transformed into a graceful white swan. I think that people and relationships are like that—feelings and situations can look pretty ugly, but if allowed to grow into what they are intended to be, can be very gratifying indeed. Hopefully, marriages are just that.

—THERESE MAY

THERESE MAY lives in San Jose, California. She began her art career as a painter but started making quilts in 1965 when her children were small because it was an artistic activity that could survive frequent interruptions. Conflicted between time spent quilting and painting, she discovered she could do both by painting on her quilts, and eventually the quilts went on the wall rather than the bed. She is inspired by folk art, found objects, and dreams.

LOAN CO is assistant pastry chef at the San Francisco Marriott Pastry Shop. She was born in South Vietnam and, after her third attempt to leave, in 1980, successfully escaped communist Vietnam and two years later achieved her lifelong dream of coming to America. She started her baking career at a small San Francisco coffee shop and in 1989 joined the Marriott. She enjoys her job because her creations bring smiles to her customers' faces.

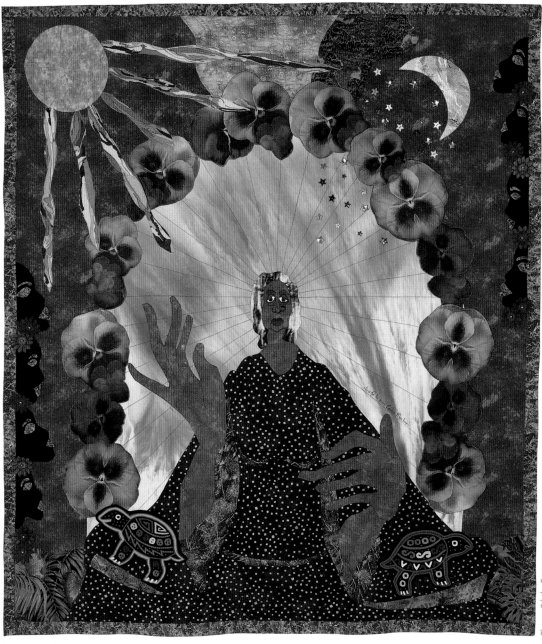

CAROLYN L. MAZLOOMI ◆ DEE-DEE TOLBER

PASS IT ON

57 x 65 inches

Cotton, polyester, and silk fabrics, and beads.
Screen printed. Machine and hand appliquéd
and machine quilted.

Dee learned to cook from her mother, who learned to cook from her own mother. This gave me the quilt's title, which celebrates three generations of women passing along not just the art of cooking, but also knowledge and wisdom. In the center is the grandmother—she's pulling her girls toward her, which is what passing it on is all about. The faces at the sides represent the at-risk teenage girls whom Dee plans to employ in her bakery. Hovering above is the spirit of Dee's daughter. Each woman is adorned with fine, flowing African cloth to celebrate her heritage. The turtles represent the Earth's life cycle, because women have the most important task on the planet—giving birth and being the "first teachers" of all humankind.

When I was invited to work on this project, I had two requirements: I wanted to work with an African American chef, and I wanted to work with a chef who was not well known. I quilt in the narrative tradition—story quilts are my love and forte. I particularly like to work with events and ideas that touch my life and my heritage, which is one of the reasons I specifically asked for an African American chef. I was hoping this project would have a lot of publicity, and I wanted someone who was not already in the limelight to benefit from that exposure. ⬦ In getting to know Dee Tolber, I learned that nothing has come easily for her. One horrific year, she suffered a parent's worst nightmare—her beautiful sixteen-year-old daughter was murdered. At this, the lowest point in her life, she struggled from deep despair to piece her life together. Dee says God spoke to her and told her to start a business baking cookies. She had always liked baking cookies but never thought of it as a business opportunity. With the help of her former employer and support from a local shopping mall, Dee started ABC Company—ABC stands for "A Blessed Cookie." Dee intends to employ at-risk girls in her bakery and wants to help show them that "they are capable of reaching the loftiest of goals. They can do something positive with their lives and can work their way out of poverty." Dee's work is a celebration of her daughter's life—out of her sadness came some good. ⬦ Much of my quilting has to do with family, or with women and their position in the family as the first teachers. Everybody comes through us—kings, queens, paupers, everybody. It's an awesome task, when you think about it. I like to celebrate family unity and the status of women in my quilts. When African people came here they brought needlework skills and the tradition of the narrative. We have a lot of things to say as a culture, so we are just in love with the narrative. I love bright colors, and when you combine storytelling with color, it's very powerful. Even if I'm not quilting, I want to surround myself with color, because it is so therapeutic to me. And we as human beings have a love affair with fabric—it's the first thing we're swathed in when we're born, and it's always with us because we wear it next to our skin. ⬦ *Passing It On* celebrates the strong and resilient spirit of women everywhere who help make our world a more peaceful and loving place to live.

—CAROLYN L. MAZLOOMI

CAROLYN L. MAZLOOMI lives in Cincinnati, Ohio. She always wanted to fly, so she earned a pilot's license and a doctorate in aerospace engineering. Upon seeing an Appalachian art quilt in 1981, she decided on the spot to teach herself to quilt. In 1984, she founded the international Women of Color Quilter's Network, and she is the author of *Spirits of the Cloth*, a pioneering book on contemporary African American quilters.

DEE-DEE TOLBER lives in Columbus, Ohio, and is owner of ABC Company. As a child, she spent summers with her grandparents, who enlisted Dee-Dee in cooking everything from scratch. She graduated from high school a pregnant, unwed teen, and went to secretarial school. With her "I can do it" attitude, in 1992 she began her business after co-workers raved about, then purchased, her cookies. She mentors young female recovering addicts and is a board member of a local council on alcoholism.

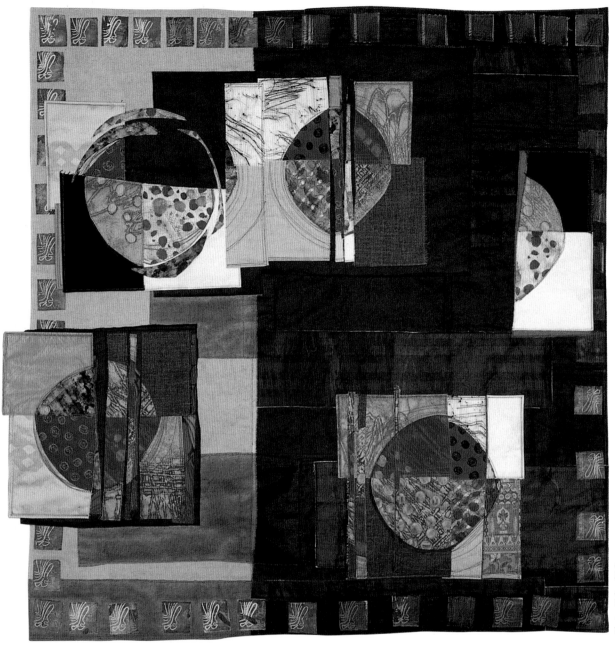

ANN STAMM MERRELL ◆ NANCY SILVERTON

OLIVE BREAD, SLICED

58 x 59 inches
Cotton, linen, silk, wool, and polyester fabrics,
and screen-door netting. Hand painted and
rubber-stamped. Machine appliquéd,
machine pieced, and machine quilted.

From an amazing day tasting Nancy's wares and going on a fabric shopping spree with her, I decided to play with depicting the Celtic cross as loaves of bread—olive bread is one of Nancy's specialties. I struggled between simplicity and control as I worked to achieve an uncontrived Celtic-cross scheme. I strove for a Nine-Patch effect, with each patch as a loaf, in the same orientation and with the same number of slices, but I worried I was trying to force it. So I thought, What about slicing each loaf any which way, in any angle, or number of slices, and reassembling the pieces however they looked right?

One designated morning, I meet Nancy at her restaurant: Over pastries and coffee, we speak more about quilts than food as I show her some of my previous work. We discuss how we're not sure what collaboration means in this case—once I start working, will I be able to take advice or input? My thought all along was to use some of Nancy's kitchen textiles, maybe old dish towels, and paint them. ◆ So there we are, talking, and Nancy says (this is the part where I start to think I'm in this totally awesome dream), "There's a fabric store across the street—want to go?" Can you imagine? Of all the quilter-chef scenarios, this has to be the best. Off we go to Diamond Foam and Fabric, not your typical chain store, two buildings more like warehouses, and almost all the fabric is on wholesale-type tubes. My idea of the collaboration now is to have Nancy pick out several fabrics she likes, and I'll buy small pieces and use them in the quilt. I see that much of this stuff is imported and in the thirty-to-forty-dollars-per-yard range. Hmmm. Well, I figure if Nancy picks three or four fabrics, I can spend that much. ◆ We walk around, checking this beautiful stuff out, and here comes Jason, the owner. Nancy knows him well—it turns out they swap *couche* (cloth for proofing bread) for food. Jason says, "I'll take the scissors and cut for you." We're off. "You like this fabric?" whack whack whack, a jagged free-form cut, a quarter of a yard. "How about this?" whack whack whack, a half a yard. This is great, except that the pieces are piling up and I seem to lack the control to say, "This is enough." I'm getting a little worried here, so I pull Nancy aside and express concern about the cost. "Don't worry," she says. "He'll give us a good discount." We end up with nine or ten pieces, maybe three or four yards' worth. We approach the register, and I await the damages. "It's yours," says Jason. "No charge. Don't worry about it." Wow. This sure is an amazing fabric store. ◆ It's getting close to noon, and back across the street customers will start arriving soon, so it's time to end our meeting. I mention that I want to buy a loaf of bread for the cousins I'm staying with, so we go into the bakery, and Nancy starts filling a big shopping bag with different breads ("Veggie sandwiches? Here, use this") and pastries. Once again, it's all free! Wow. I pack up all the prizes, and we say goodbye.

—ANN STAMM MERRELL

ANN STAMM MERRELL passed away during the compilation of this book. She lived in Cupertino, California. Ann grew up sewing and was raised in a community that made and valued quilts. She began quilting as an adult in 1984, when she took her first and only class. She served as the liturgical artist-in-residence at her church, and was also a professional saxophonist and composer. Until 1993, she made quilts with straight lines and perfect angles, but her breast-cancer diagnosis moved her to work more freely.

NANCY SILVERTON is pastry chef, baker, and co-owner of Campanile, a restaurant, and La Brea Bakery, in Los Angeles. In college, Nancy worked as a vegetarian cook in her dormitory kitchen. In addition to early restaurant work, she attended the Cordon Bleu in London and studied pastry-making in France. After serving as head pastry chef at Wolfgang Puck's Spago, Nancy opened Campanile and La Brea Bakery with her husband, the chef Mark Peel. Nancy has written two cookbooks; and co-authored two with Mark.

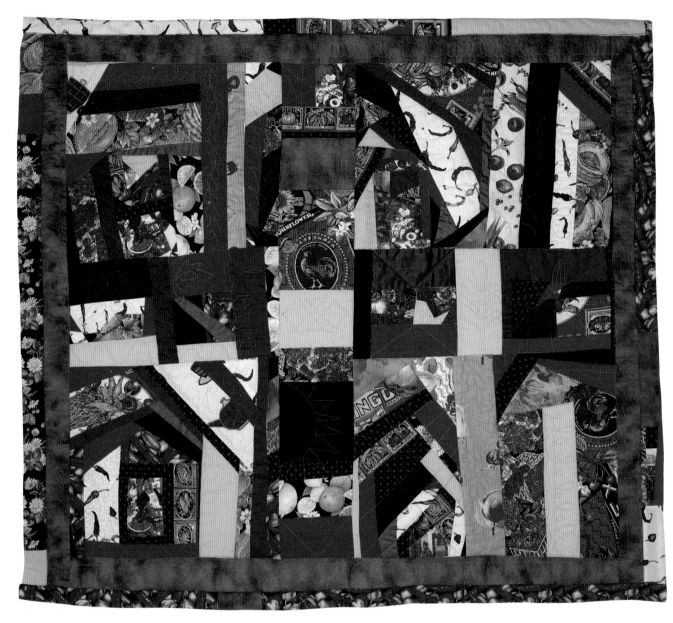

Photo: Sibila Savage

ED JOHNETTA MILLER ◆ SHERRIE MAURER

LIGHTING THE FLAME

57 x 52 inches

Cotton, blended, and silk fabrics, including vintage flour sacks and 1940s food fabrics from the Salvation Army. Silk hand painted and images photo-transferred. Machine pieced and machine quilted.

When I first saw Sherrie, on a talk show, I never thought I'd meet this amazing woman face to face. Then, two years ago, who should I encounter at an African American marketplace, but Sherrie! We clicked immediately, and I asked her about her life and how she got started as a black woman entrepreneur. It's from these stories that I made the quilt, which includes a green border for Sherrie's "no"-means-green-light attitude; South American molas, my way of saying "Look at us on this beautiful cross-cultural quilt—we can all come together"; old flour sacks, like Sherrie's grandmother wore as aprons; photos of Sherrie with her family; my painted silks as a piece of me; and food fabrics gathered by the seniors I teach, to make it a community thing.

always had a longing to be an artist, but when I was going off to college, in the late 1960s, my parents said, "It's hard enough for a young black woman to get along in life, and you want to be an artist? Are you for real?" So I put my dreams on the back burner and studied business administration. But after working in the business world, at a certain point I had to follow my heart and let the artist in me take over. I think all of us have visions of being our own boss, but maybe we don't know what exactly we'd do. So we go through life working for other people and fulfilling their dreams, and, to a certain extent, we're fulfilling our own dreams, too. But then an opportunity or an inspiration comes along, and we make a move, and that's what Sherrie did when she opened her business. ◆ Sherrie started Jasmine & Bread in 1983, after a racial-discrimination suit against a former employer left her feeling horrible about herself. Sherrie's husband says that telling her "no" is like giving her a green light to go, and Sherrie agrees: "Every time someone said I wasn't good enough, I set out to prove that I was." While growing up in inner-city Indianapolis, Sherrie learned to cook at her grandmother's side. Her grandmother cooked for wealthy families, and, says Sherrie, "She'd sneak me in on Saturdays. . . She had an artistic eye for preparing food." Sherrie told me she'd like to see more black women out there in the food business because "We are dynamic cooks. We've been cooking for other people forever." ◆ Like Sherrie with her grandmother, I was fortunate to have an aunt who always encouraged me. I would sit at her knee while she was quilting, or crocheting, or knitting, and she would show me how and let me explore. Sometimes I think I'm fulfilling my aunt's dream, becoming that artist she wanted me to be. Over the years lots of people have encouraged me. My first major art love was weaving, and I was a weaver for twenty-four years until Carolyn Mazloomi said to me, "Your woven pieces look like quilts. Have you ever thought about quilting?" Now quilting is my passion—it has taken over my whole life. I love it, I teach it, I share it with young people and older people. Sherrie is also full of life and excited about what she does. This summer, I'm going to visit Sherrie and her family in Vermont and learn to cook her way. And when the quilt comes back from its tour, I'm going to give it to Sherrie. She'll be in my life forever.

—ED JOHNETTA MILLER

ED JOHNETTA MILLER lives in Hartford, Connecticut. Though she studied business administration, she has spent her working life in public service and art. She has apprenticed with master weavers and is self-taught as a silk painter, quilter, and creator of wearable art. She curates exhibitions and collects African American story quilts and crafts. She is currently a master teaching artist for the state of Connecticut and the Greater Hartford Arts Council, and directs arts programs for seniors and young people.

SHERRIE MAURER is owner of Jasmine & Bread, a specialty-foods company that features all-natural "condiments beyond compare" in Sharon, Vermont. She has worked as a waitperson, hotel caterer and manager, and potter. After friends begged her to make more of her special catsup, in 1983 she started her company, educating herself from scratch about small businesses and calling on help from family and friends after being turned down for a loan.

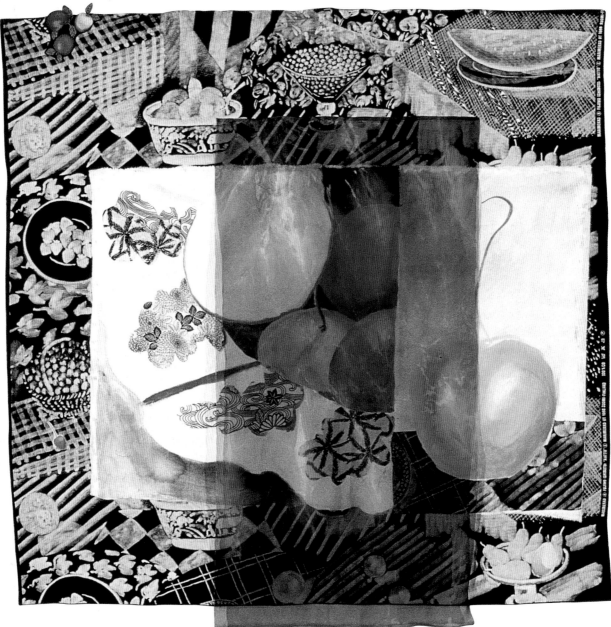

Photo: Tom Yarish

MIRIAM NATHAN-ROBERTS ◆ MICHELE H. FAGERROOS

CHERRIES³

57 x 57 inches
Cotton, painter's canvas, and polyester
organza fabrics. Hand gessoed and painted.
Machine appliquéd and machine quilted.

I have a fixation with cherries, so my first question to Michele was, "How do you feel about cherries?" She said she rather liked them. Truth be known, I had already started a piece about cherries, and I showed her what I had so far. She liked it, and over the course of the quilt's creation we discussed recipes, had fun, and got to know each other—a delightful bonus of the project. This quilt started its life three years ago as a painting, based on another painting by a little-known seventeenth-century artist, Louise Moillon. The three in the title refers to the three "cherries," Louise, Michele, and myself—a collaboration of three women of taste.

A few years ago, I realized that I had long been collecting fabrics illustrating cherries. And then I noticed I was making the rounds at antique stores buying all manner of cherry-adorned items—trays, tins, tablecloths, pictures. I decided this fetish was very corny, and I was going to exorcise my cherry devil by doing a quilt about cherries that would use up all my cherry fabrics. But I ended up painting most of the cherries and not using the fabrics at all, and the quilt was the most enjoyable one I had made in years—it did not even begin to cure me! I had kept this fetish a secret, but it was time to finally come out of the closet and accept the fact that I seem not to be able to resist the sweet little fruit. ◆ I recently returned to painting after a thirty-year hiatus, and enrolled in an ongoing class to get my chops back. One of the assignments was to take a painting by someone else, blow up a detail, and paint that. I looked through the book *Women Artists* and found *Still Life with Cherries, Strawberries, and Gooseberries* (1630) by Louise Moillon. In painting this detail, I realized in part what my cherry fixation was about—the shape. Though most of my quilts have been quite geometric and linear, and much of the art I admire has hard edges, when I myself am painting I tend to paint circular images. I'm an action painter—I enjoy the actual physical movement of painting circles. ◆ I was happy to include Louise Moillon in this quilt because classic histories of Western art mention very few women, despite the fact that women have always made art. Part of the reason quilting has been marginalized is because women have done it. I once went to a quilt show and saw an Amish piece consisting of squares within squares. The label said the quilt was reminiscent of Josef Albers, even though the quilt was made fifty years before Albers was born! Because *Cherries*[3] contains such a significant amount of painting—and on gessoed painting canvas rather than sewing fabric, at that—it's up for grabs whether it's a painting or a quilt. If much of it is painted, would it then be considered art rather than craft? ◆ I combined the painting with some black-and-white Marimekko fabric that had been my favorite material for years—so favorite that I had been afraid to use it! Hanging over the painting is a piece of organza. As people move by the piece, they create a draft and see changes in light and color through the moving translucency. Michele liked the quilt, and said she enjoyed "creating something that wasn't perishable."

—MIRIAM NATHAN-ROBERTS

MIRIAM NATHAN-ROBERTS lives in Berkeley, California. She studied textiles and design as an undergraduate and earned her master's degree in educational psychology. She turned to quiltmaking in 1972 because she loved fabric (she calls herself a "fabric fondler") and color, and felt there was more room for creativity than in the other textile arts she'd done. When her husband proposed, he sweetened the pot by telling her he'd gotten a job in a premier fabric store that yielded him a twenty-percent discount.

MICHELE H. FAGERROOS is pastry chef of Citron, in Oakland, California. As a child, she couldn't wait for cartoons to end so she could watch the cooking shows, especially Julia Child's. She grew up baking with her family and with a German babysitter who liked to make cakes. She never wanted to be anything other than a pastry chef. After one year of college, she indulged her lifelong sweet tooth and went to cooking school, and has been working at Bay Area restaurants ever since.

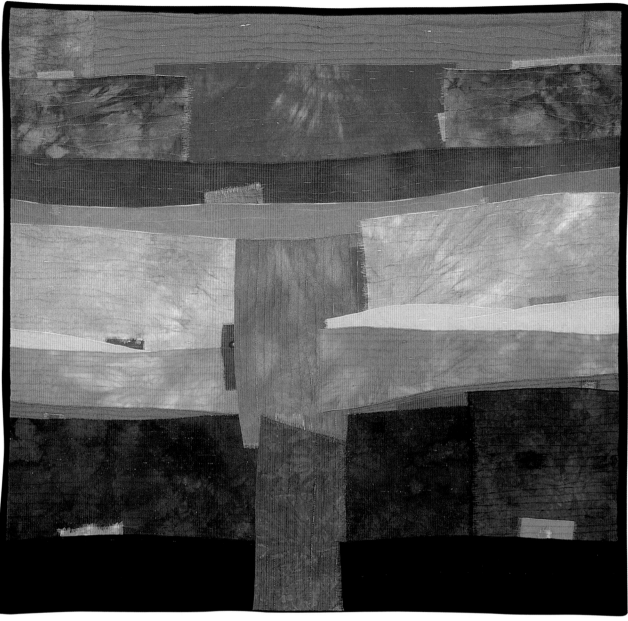

JEAN NEBLETT ◆ LYNN SHEEHAN

REFLECTIONS 1: SONOMA

49 x 47 inches
Cotton fabrics. Hand dyed.
Machine appliquéd and machine quilted.

As Lynn and I were initially neither clear nor comfortable with the process, we had to feel our way through what we imagined was expected of us. Our collaboration consisted mostly of talking about our lives, our experiences, the environment, and our dreams. We also leafed through a book of contemporary art quilts together while Lynn indicated her preferences. The inspiration for this quilt, a landscape, was Lynn's dream of owning a restaurant in Sonoma, California, where produce and herbs would come from her own garden and from the fields of local growers.

Although Lynn and I met only five times, we became very warm with each other. She is loquacious, perceptive, and very bright, and asked a myriad of questions. As Lynn spoke of her life, it was obvious that food is her passion. She vividly described her childhood, her move from the Midwest to California, the joys of youthful gardening, and a pursuit of purity in food. I worry we've lost touch with nature, and I share this pursuit with Lynn—I'm a vegetarian and I eat organic food, and participate in community-supported agriculture. With a neighborhood group I organized, I subscribe to a farm. Every Tuesday the farm delivers fresh produce to my area, and over the next week I cook with whatever's in my box. ◆ Since I don't do representational work in my quilting, I didn't know where I would go with this project. As the deadline rapidly approached, I began laboring on a piece that fought me all the way. There's value in taking struggles to a certain point and working your way through problems, especially as a beginner, but sometimes you have to decide just to let it go. With experience and intuition, you learn where that cut-off point is. On the theory that this piece did not wish to be born for this project, I abandoned it and began anew. ◆ The result, *Reflections 1: Sonoma*, came very swiftly, as if it had been waiting at the gates for the opportunity to enter. My biggest art influence is work from the late 1940s and 1950s, especially the early California Abstract Expressionists, and I think that shows here. I share Lynn's love of Sonoma; to me, *Reflections 1* is about place, and in this way the piece meant something in the context of my collaboration with Lynn. The quilt conveys the feel of Sonoma—the colors, the contrast between the rolling hills and the trees. The greens in the center are upright, alluding to the arboreal areas, but the rest of the landscape is much more horizontal, with greens representing Sonoma's colors in the winter and yellows referring to the drier summer. At the bottom, the dark green represents all the trees in the area. ◆ All my work has been profoundly influenced by my background in painting, modern dance, modern jazz, and the design of interior space. An upbringing involved with fabric and sewing also shapes my sensibilities. I frequently focus on issues of density and layering, whether visible or hidden. In that vein, this quilt actually began a series for me, *Reflections*. I'm now on the fifth piece in the series, which consists of reflections of my life and of places meaningful to me.

—JEAN NEBLETT

JEAN NEBLETT lives in San Francisco. Although she has been quilting only since 1986, she grew up sewing with her mother, aunts, and grandmother, and is a self-taught fiber and textile artist of many years. She has owned businesses, which create and sell handmade sweaters, hand-hooked rugs, and wearable art. She has designed catalogs and sales displays, and wrote a book on cooking for hikers. She currently designs and renovates interiors, works in real estate, and promotes neighborhood preservation.

LYNN SHEEHAN is executive chef of Vertigo Restaurant and Bar, in San Francisco. For over twelve years, she has worked in some of the Bay Area's finest restaurants. Her own palate runs to contemporary Mediterranean fare inspired by regional flavors, celebrating freshness, sensuality, and the elemental balance of food prepared simply and with integrity. Her interest in sustainable agriculture and produce at its peak is supported by her ongoing relationships with small local growers.

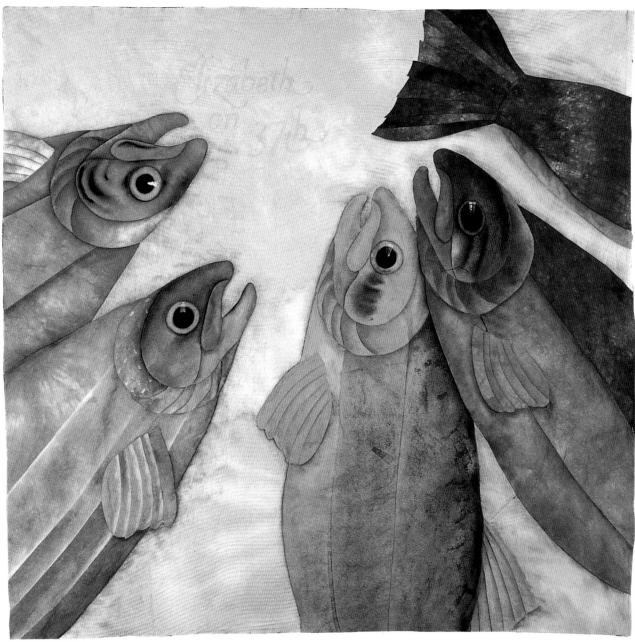

VELDA E. NEWMAN ◆ ELIZABETH TERRY

CATCH OF THE DAY

58 x 56 inches

Cotton fabrics and iron-on foil.

Hand dyed, hand drawn, and hand painted.

Hand appliquéd, machine pieced and

machine and hand quilted.

When I heard Elizabeth ran a five-star restaurant, I thought, Well, I'd better go and check this out. So I traveled to Savannah, stayed in her guest house, and ate the most wonderful meal at her restaurant. Elizabeth was truly delightful. I also drew inspiration from her cookbook, which includes stories about her life and family in addition to recipes. One ribbon that runs through the book is that her family loves to sport fish. Of course she also serves glorious seafood in the restaurant. I kept coming to the fish theme, which Elizabeth thought was a great idea for the quilt.

My approach to quilt design is similar to a painter's approach to painting. I use color, composition, and scale to capture the spirit of nature, but through the medium of textiles. Nature's colors and patterns are the essence of my designs, but scale is what makes them unique. Many classic works of art depict nature on a scale smaller than real life. A landscape places you in a relatively distant position, and even a still life may portray the subject at less than its actual size. I do just the opposite—I take life and amplify it. My quilts might not be really large pieces, but their scale is larger than life, which affords much more detail as well as emotional and visual impact. ◆ I learn a lot about the subjects I study for my quilts; observation is a key element of what I do. For example, many people, if they were drawing a tree, would depict a brown trunk and green leaves. But that's only one combination out of a thousand. I enjoy picking out the little details that people don't really notice. When I put them into such a large scale, people are urged to see more intensely. Sometimes I work from photographs, close-up shots I've taken. Other times, before choosing a detail, I study whatever I'm going to depict. If I'm creating a flower quilt, I get a big pot of, say, hydrangeas, and leave it on my kitchen counter for a couple weeks. Every time I walk by, I look at it, and after a while I start drawing. I did not, however, live with fish on my kitchen counter for two weeks. My sons and my husband are fishermen, so I've been around fish for a long time. I worked from memory and from pictures of fish my sons have caught. ◆ In my pieces, I strive for depth and realism. I want fish to look like fish. Elizabeth works with fresh foods, so it was important that the fish look like they had just washed up onto a beach. She doesn't make what one might imagine as Southern food. To me, it's closer to what I think of as California cuisine, though Elizabeth says it's not new—her recipes descend from "company Southern cooking," not heavy working-class fare but the elegant, lighter dishes that accomplished Southern cooks concocted for friends, guests, and extended families before the turn of the century. To make our fish look as fresh and realistic as possible, I dyed and painted all the fabrics, starting only with white cotton, and added glints of foil as accents. The fish lie on a bed of sand, from which the stipple-quilted name of Elizabeth's restaurant faintly emerges.

—VELDA E. NEWMAN

VELDA E. NEWMAN lives in Nevada City, California. She studied art in college, focusing on painting, but set aside her artwork when she married. Though she'd always liked quilts, she didn't enjoy piecing traditional designs. About fifteen years ago, on a whim she created a representational appliqué piece to enter into a quilting contest. That quilt won a prize, and Velda found her medium. She is the subject of a book, *Velda Newman: A Painter's Approach to Quilt Design.*

ELIZABETH TERRY is chef and co-owner of Elizabeth on 37th, in Savannah, Georgia. When she got married, her husband gave her two cookbooks and said "You'd be good at this." She opened a sandwich shop in Atlanta in 1978, and in 1981 opened Elizabeth on 37th. The eatery is located in a turn-of-the-century mansion, and the Terry family lives upstairs. With her daughter, Alexis, she is the author of *Savannah Seasons.* Her business philosophy is not to get bigger every year, but better.

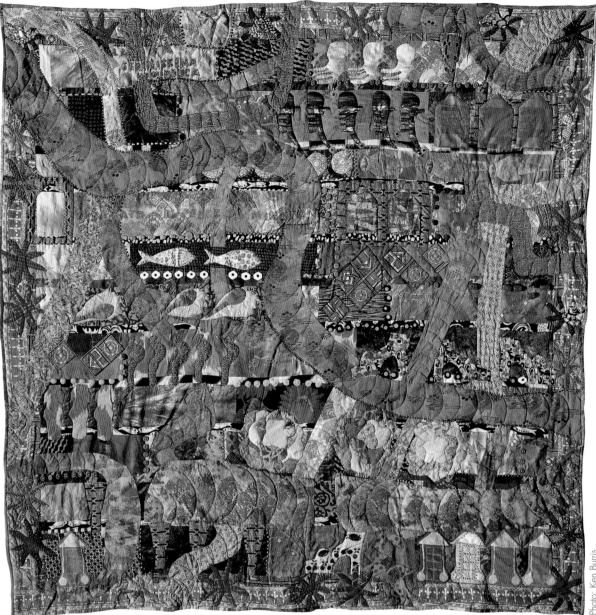

Photo: Ken Burris

ELIZABETH CHERRY OWEN ◆ MARCELLA HAZAN

FRUTTI DI MARE DI VENEZIA

59 x 58 inches

Cotton and velvet fabrics, antique Fortuny fabric,
mirrors, and new and antique Venetian beads.
Hand dyed and rubber-stamped.
Hand appliquéd, machine pieced, hand quilted,
hand embroidered, and hand embellished,
including Indian mirrorwork.

I asked to be paired with Marcella because it was through her writing that I learned both to cook and to love Italy. To this day, Italian food is what I feel most comfortable preparing. The Women of Taste project coincided with the publication of Marcella's most recent cookbook, *Marcella Cucina*, which celebrates Venice. My early meetings with Marcella were taken up with discussions of this city and its distinct cuisine. She showed me her favorite Venetian cookbook (illustrated with beautiful photographs), and suggested that I think about different kinds of fish, pasta, and fabric. Eventually I decided a "research" trip was in order, and I visited Venice armed with recommendations and introductions from Marcella and her husband, Victor.

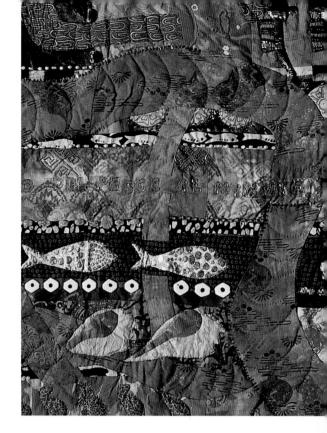

n the 1970s, Marcella's *Classic Italian Cookbook* was featured in a book club I belonged to, and after it arrived in the mail I proceeded to learn all the basics of cooking, everything from deboning chicken to peeling a tomato. Marcella is very, very precise. She was trained as a scientist, so she can explain on a chemical level why things work in a particular way, phenomena that Italian cooks figured out hundreds of years ago by accident. She has a wonderful partnership with her husband—she talks about what she's cooking, and he writes it all down. I interacted with both of them during the making of this quilt, and it was wonderful to see such a flawless team. ◆ I found myself stymied as I began, so my sister and I planned our ten-day visit to Venice, where I had never stayed for more than an afternoon. What a stimulation of the senses! My background is in art history, and I have always been drawn to Catholic countries and Catholic art and iconography. We walked everywhere, sampled all kinds of food, looked at art, and visited churches. The Hazans recommended a restaurant to my sister and me, so small and out of the way that I don't think the restaurant or its street had a name. When we told the waiter that the Hazans had sent us, we were seated at a lovely table and treated to the most delectable meal. We spent an entire morning at the fish market where Marcella shopped, and at her suggestion noted all the different colors of radicchio and vegetables. That night, as I lay jet-lagged and awake in bed, I formed the idea for my quilt. What if I created registers of imagery, like Egyptian hieroglyphs, organized after a medieval mosaic of the Last Judgment in a Venetian church, and superimposed onto these layers a map of the canals? ◆ Back home, I filled the quilt with appliquéd mementos of Venice. I dyed and stamped fabric in an effort to convey the beautiful, crumbling buildings, layers peeling away in soft shades of pink and green to reveal more ancient and time-worn layers of history. All around the quilt's edges are flattened-out octopi, which are abundantly served in Venetian restaurants. At Marcella's suggestion, I took note of the Venetian chimneys, rows of chimney pots in different shapes, and these appear throughout the design. I found some old Fortuny fabric in a Venice antique store, which I had to have for the quilt, and embellished the damaged spots with traditional Venetian lace embroidery. Italian vegetables are rubber-stamped throughout. Frutti di mare (fruits of the sea) is the poetic Italian phrase for shellfish, but the title of this quilt expands the meaning to a more metaphorical sense.

— ELIZABETH CHERRY OWEN

ELIZABETH CHERRY OWEN lives in Baton Rouge, Louisiana. In 1982, she was looking for ways to distract herself from her master's thesis in art history. A school colleague made quilts, and Elizabeth asked for instruction. She became infinitely more interested in quiltmaking, and never wrote the conclusion to the thesis, which remains unfinished in her attic. As her quilts have evolved away from the traditional, she has become less verbal about them, less the art historian.

MARCELLA HAZAN recently moved to Longboat Key, Florida, from Venice, Italy. After earning a doctorate in biology in Ferrara, she married and followed her husband to New York. Lonely and homesick, she learned to cook from a book her husband bought for her. Many years later she opened their New York apartment to Italian cooking classes. Her 1973 *Classic Italian Cookbook* was an immediate hit and profoundly influenced American cooking and eating. Her latest book is *Marcella Cucina*.

The quilt text reads: SEASONAL · ORGANIC · INNOVATIVE · MAY · JUNE · JULY · AUGUST · SEPTEMBER · OCTOBER · CREATIVE · SUSTAINABLE · BAKING · FRESH · HEALTHY · PEPPERS · PICK OF THE · FEBRUARY · MARCH · APRIL · JANUARY · DECEMBER · NOVEMBER · EXCITING · NUTRITIOUS

Photo: Breger and Associates

SUE PIERCE ◆ NORA POUILLON

GOOD FOOD: A PLAN FOR ALL SEASONS

57 x 55 inches

Cotton and blended fabrics.

Images and letters rubber-stamped.

Machine appliquéd and machine pieced.

Machine quilted by George Anna Lunking.

When I met Nora, I was taken by the fact that her philosophy of food preparation is far more than a business plan for a successful restaurant—healthy, seasonal, and sustainable is clearly a way of life in which she believes strongly. After Nora suggested a seasonal approach to the quilt (her cookbook is also organized around the four seasons), I examined her menus and food presentation. I worked with Nora to compile a list of foods in their respective seasons as well as an assortment of words that Nora felt described her work, and these are the elements that appear on the quilt.

Knowing Nora and her restaurant by reputation, I felt somewhat intimidated coming into this project. My family food background consists of the meat-and-potatoes cuisine of northern European immigrants. While I consider my own kitchen to be a somewhat healthier adaptation of those ideas, I'm not a gourmet cook and am somewhat ignorant of the ingredients that have gained favor in recent years. I worried that I would not speak Nora's language and wondered how to bridge the gap. ◆ When we met, however, I was taken by Nora's graciousness and by her philosophical approach: she promotes a healthy lifestyle as well as good restaurant food. I had initial difficulty, however, coming up with a visual representation of such a broad spectrum of rather abstract ideas. How do you picture an organically grown vegetable as differentiated from the average supermarket item imported from thousands of miles away? How do you depict the freshness and flavor of just-picked corn? How can you show the nutritional value of good food? In the end, Nora came to the rescue by suggesting a seasonal approach. After I decided to create the quilt from four season-themed panels and developed my food lists with Nora, I began the design process. ◆ Using both photographs and in-season items as models, I started drawing individual vegetables, fruits, and edible spring flowers. Though Nora's menu is not vegetarian, adding meats seemed problematic for the composition. Seafood would have worked well, but how to deal with, say, lamb? A whole animal would be out of scale, and a cut of meat seemed very unattractive. ◆ I sought fabrics in the colors of the garden, particularly those with prints that would lend themselves to the look of the actual items (in the end, I used over seventy different fabrics in the quilt!). I then began to cut and arrange shapes, seeing as I went that I needed more color for some and larger shapes for others. I designed each panel as an individual still life while considering how they would combine into one quilt. Though I never want words to be the main focus of my artwork, I decided text would best introduce additional information about Nora's philosophy, and stamped the borders. ◆ Completing a quilt is somewhat like giving birth after months of gestation—you are thrilled to be done, but reluctant to send your "baby" off into the world. I am not only pleased with my quilt but also glad that I stuck with a challenging project.

—SUE PIERCE

SUE PIERCE lives in Rockville, Maryland. Fifteen years ago, she decided to rent studio space at an artists' cooperative, a major professional turning point because it afforded separation of work and home responsibilities as well as cross-pollination with other artists and their different media. She is involved with several arts organizations and originated the Full Deck Art Quilts project, the first exhibition of contemporary quilts to be shown at the Smithsonian. She is co-author of *Art Quilts: Playing with a Full Deck*.

NORA POUILLON is chef and owner of Restaurant Nora and Asia Nora, in Washington, D.C. When American supermarket produce tasted different from the wholesome, seasonal food of her childhood in Vienna, she began using organic foods and is a pioneer in that arena. She started a cooking school in 1973, opened Restaurant Nora in 1979, and serves as consultant on such food issues as better public-school lunches. She is the author of *Cooking with Nora*.

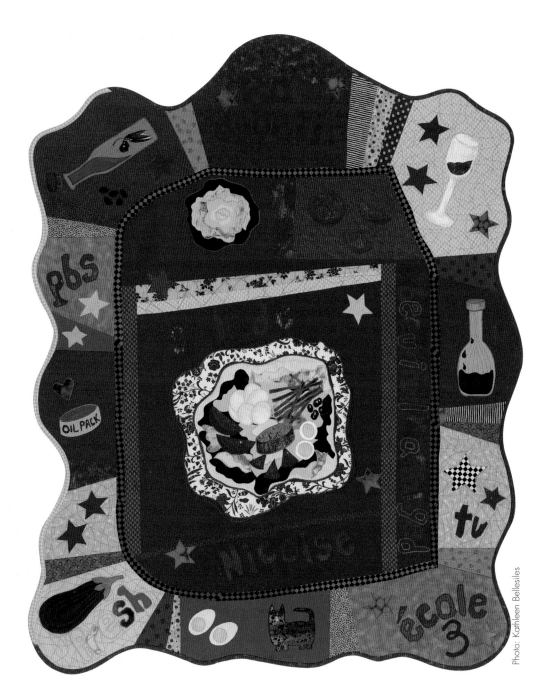

Photo: Kathleen Bellesiles

YVONNE PORCELLA ◆ JULIA CHILD

BON APPÉTIT

49 x 62 inches
Cotton fabrics. Hand painted and drawn.
Machine appliquéd, machine pieced,
and machine quilted.

Julia and I decided that the major theme for our quilt would be *salade niçoise*. Because Julia is such a unique personality, I chose curved borders— definitely not something so plain as a rectangle or a square. I imagined looking down at a table with chairs surrounding the center board, with the curved-back chair shapes as different design areas. I used a piece of Souleiado French fabric for a salad dish to evoke Julia's experiences in France, and because in all photographs of Julia's kitchen one can see a wall-mounted display of blue-and-white china dishes in the background. Other details were inspired by Julia and her remarkable career.

When my husband and I picked Julia up at her winter home in Santa Barbara, it was a beautiful sunny day. We enjoyed lunch at a local restaurant she recommended, and after our fresh California cuisine she suggested we talk about the quilt. ◆ I had prepared myself for our collaboration by reading all I could about Julia. In addition to what I already knew, I learned that Julia considers herself an educator and a cook, not a celebrity. Unlike most well-known culinary mavens, she has never owned or worked in a restaurant. Throughout her career she has taught as well as toiled to create perfect recipes through endless testing and experimentation. ◆ Julia suggested that a "jolly" quilt full of color, maybe tomatoes or straw-berries, would be a good place to start: "Perhaps a *salade niçoise* would be nice, since it contains such colorful ingredients. Begin with fresh-boiled potatoes arranged on a bed of lovely green Boston lettuce, add tuna . . ." From there the conversation diverted to a discussion of the virtues of tuna in its different forms—Julia insisted that canned, oil-packed tuna tastes much better than water-packed, and that a tradi-tional *niçoise* salad would not have fresh tuna. Julia repeated to me her oft-quoted philosophy—eat a variety of foods with small helpings in moderation and have fun cooking. All ingredients should be the best quality one can obtain, and every dish should be beautifully arranged. ◆ Back in my studio, I designed the *niçoise* elements into a salad that forms the center of the quilt, then continued the story in the border. Fine olive oil and vinegar make up the dressing. Although eggplant is not found in the traditional *salade niçoise*, Julia and I agreed that a good eggplant dish is hard to ignore—we both like eggplant fresh and prepared in a variety of ways. ◆ Explaining that she and her husband, Paul, were fond of cats, Julia asked me to put two on the quilt, though my design originally called for just one. The adjacent hard-boiled egg is also significant: Julia and her husband had a tight partnership throughout their marriage, so I took a single hard-boiled egg (one of Julia's many accomplishments has been to concoct the perfect formula for this simple creation) and divided it into two perfect halves. ◆ And of course, I had to reference the most memorable image of Julia from her television shows—her holding up a glass of wine at the end of each show and toasting the audience with a distinctive, "Bon appétit."

—YVONNE PORCELLA

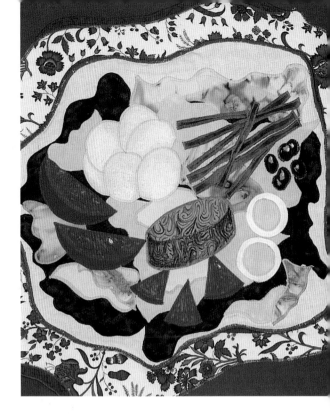

YVONNE PORCELLA lives in Modesto, California. She studied science in college and worked as a nurse for many years, but taught herself to weave on a child's loom because of a desire to sew with original fabric. She started creating wearable art, combining patchwork with her woven textiles, and in 1980 these pursuits evolved into quiltmaking. She founded the advocacy and support organization Studio Art Quilts Associates, and is the author of eight books.

JULIA CHILD lives in Cambridge, Massachusetts, and Santa Barbara, California. As a passionate, accessible educator and interpreter of French cooking, and an advo-cate of good ingredients prepared well, Julia has been an undisputed pioneer in the trans-formation of cooking in the United States. Starting in 1961 with *Mastering the Art of French Cooking*, her cookbooks have become classics, and with *The French Chef* she gave birth to the first television cooking show. For almost half a century, she has enthusiastically devoted herself to teaching, writing, and cooking.

81

Photo: Sibila Savage

The following words appear on the quilt image:

"While women developed the techniques and the tools for cooking, it was the men who wielded the knife - the tool that was used to dominate and conquer."

Comfort food

Respects tradition

Collaborative

Dominates

Nurtures

Competitive

Lectures

Cooperative

Architectural food

Team building

Pushes new limits

Collegial

Egocentric

Works alone

"I remember the woman's side of things: the nurturing, the food, the hospitality."

ANN A. RHODE ◆ KATY KECK

BALANCE OF POWER

56 x 56 inches

Cotton fabrics. Images photo-transferred.
Machine appliquéd, machine pieced,
and machine quilted.

As Katy spoke to me about studying business, working on Wall Street, and cooking in France, I realized how much experience she'd had in competitive worlds that were almost exclusively male-dominated. Katy is definitely a feminist, and from our initial meeting we realized that the contrast between male and female kitchens would make our quilt, perhaps even with a social message that poked some fun at men at the stove. Since we've both traveled to France and the Far East, I used French and Japanese fabrics. The words come from a list I asked Katy to compile of differences she's perceived between male and female kitchens. The yin/yang design allows the piece to work from a distance.

During a trip to New York, my daughter and I visited New World Grill, where we met Katy on a beautiful plaza adorned with a fountain of four women holding up the world with male heads spouting water at their feet. As Katy ordered our food, I showed her some examples of my quilts, and we exchanged life stories. She seemed to respond most to *The Oldest Men's Club at Work*, my fabric reaction to the Clarence Thomas–Anita Hill sexual harassment hearings. ◆ I'd been surprised by the spontaneous evolution of that quilt, because I'd never done a political piece before. My daughter has always called me the perfect "Tollhouse mother," after the chocolate-chip cookies, but she says "You're the most liberated Tollhouse mother I know"—I've essentially been a housewife but my opinions are very much of the feminist stripe. Maybe the combination comes from growing up in the rural Midwest and watching women work side by side with men—in order to be a success on the farm, men and women have to cooperate. It always seemed to me that women should be able to do anything men can. ◆ Since we left our Midwestern childhoods Katy and I have led very different lives. After working on Wall Street for seven years, she went to France to apprentice in male-dominated kitchens in Chartres, a city I love. She told me that chefs in France held no expectations of her—she was a woman, didn't speak French, and was American, so anything she did correctly was a surprise. She has been influenced by the Far East, and I love Japan, and have great memories of my trip there—more points of connection. From all these themes, the quilt itself flowed rather easily, my second "political" piece. ◆ One of the reasons I wanted to do this project is because I had recently had a wonderful collaborative experience with another nonquilter, my brother, who wanted a quilt about himself as a fisherman. I loved exploring his passion for fishing, trying to interpret his vision and mingle it with my own. After finishing the quilt, we went fishing together. Now we both have a new respect for and understanding of the other—I was pushed to try new things, and he has a quilt that's more than "pretty" because he feels a part of it. I'm currently planning collaborations with many of the people who are close to me. My final quilt in this series will be autobiographical, a collaboration with myself.

—ANN A. RHODE

Respects tradition

ANN A. RHODE lives in Berkeley, California. She grew up on a farm where it was a daily necessity to make things by hand, and started sewing in 4-H when she was ten years old. She began quilting in 1979, by contributing to raffle quilts for her children's school. The raffle-quilt organizers soon introduced her to the East Bay Heritage Quilters, which over the years has provided encouragement, community, and exposure to nontraditional quilt design.

KATY KECK owns Savoir Faire Foods and is executive chef and co-owner of New World Grill, in New York City. At eight, she was awarded a prize for her butter cake at the Indiana 4-H fair. After earning an MBA and working in finance, she won an apprenticeship cooking in France and never returned to Wall Street. Upon her return, she created Savoir Faire Foods, a freelance consulting and styling business, and in 1993 opened New World Grill.

Photo: Sibila Savage

LYNN RICHARDS ◆ KAREN WEHRMAN

THE SEEDS WERE SOWN EARLY

53 x 62 inches

Cotton fabrics, including vintage prints.

Handwriting photo-transferred onto back of quilt.

Machine pieced and machine quilted.

In *The Seeds Were Sown Early*, I worked to translate into cloth the close friendship between Karen and myself, emphasizing our mutual experiences creating physical, emotional, and visual communities for others and ourselves and our commitment to collaboration. While we were working on the design, we put explanations of the project on the tables of Karen's restaurant, and asked patrons to write out messages of good will or thoughts about the restaurant and their favorite dishes. I eventually transferred these onto fabric and pieced them to create the back of the quilt. For the front, we determined that a range of fabrics, new and old, would represent the diversity of people, food, and ambience.

Collaboration has been a common thread in my long friendship with Karen. Over the sixteen years that I've worked at Girls Incorporated, Karen has held different positions on our board of directors. I have been consistently drawn to Karen's approach with staff—thank-you notes, special treats at holiday times, flowers in recognition of a job well done, and even financial support for a family scholarship I sponsored through the organization. ✦ Our most significant collaboration, however, has been this very project. Karen changed careers from real estate to culinary arts seven years ago, and she has since organized Bay Area women chefs into an annual fundraiser for Girls Incorporated. I saw the opportunity to include quilt art in these food showcases, then thought of pairing artists and chefs to create quilts together. ✦ While Karen and I met regularly to plan the overall project, she was at the same time opening her own restaurant. Watching her, I realized how many questions, decisions, and concerns were involved. What came across most clearly, however, was Karen's desire to create community. She was working to build not only a restaurant where people could come together to experience good food, but an inclusive, nurturing, welcoming environment as well. ✦ Starting our own quilt was a moment of truth for me—it was one thing to create this project for everyone *else*, but my own participation was very unfamiliar territory. Even after so many years of friendship, I still worried that our styles might not be compatible, and if that were the case, how could I possibly change chefs? How would my more intuitive, loose, graphic-arts-oriented approach combine with her sophisticated, defined, and clean style? ✦ Once we began sifting through my previous quilts, those concerns began to fade. As we shared everything from eggplant recipes to Fiestaware colors to larger, philosophical subjects such as art and life, I formed a vision that incorporated people who frequent restaurants, the colors of Karen's restaurant, and an overall ambience of strong, feminist good taste. ✦ I thrive on collecting and using wide varieties of fabrics (new, vintage, ethnic, hand-dyed—everything!) and on mixing different prints together in one piece. A little trademark of mine is that I never ever use solid fabrics. For this project, I collected fabrics that illustrate a broad assortment of fresh, healthy foods; a diverse mix of people (young, old, male, female); and suggestions of the tasteful look, color ambience, and architectural feel of Karen's restaurant. I put all these together in a playful yet sophisticated approach that suggests our notion of community.

—LYNN RICHARDS

LYNN RICHARDS lives in Berkeley, California. Her only childhood sewing experience was a Brownie apron project, but other early artistic interests, nurtured by her mother, led to study and employment in photography, graphic design, anthropology, Native American tattooing, and arts education. A brief business venture creating cloth-covered journals in the mid-1980s sparked an interest in square fabric objects; napkins and tablecloths soon gave way to quilts. Since 1983, she has been a program developer with Girls Incorporated.

KAREN WEHRMAN is chef and owner of North End Café, in San Leandro, California. Karen sold real estate for thirteen years but wanted to change careers and enrolled at the California Culinary Academy. After graduation, she worked at Bay Area restaurants including Greens, opening her first restaurant, Paradise Isle, in 1983, and North End Café in 1996. She has been involved with Girls Incorporated for many years.

REBECCA ROHRKASTE ◆ THERESA ROWLAND

RESONANCE

58 x 50 inches

Cotton fabrics. Machine pieced and machine quilted.

Theresa and I share the experience of early loss, and that became the basis for the quilt. In looking at my previous work, she and I talked about colors and designs—she likes the colors of water, blues and greens, and circular images. We discovered that water was an image of tranquility for both of us—Theresa compared the feeling of being in water to the ease and focus (or flow) she finds in her cooking, which I also experience while quilting. From this, I arrived at the image of ripples expanding from drops of water on a pond as symbolic of the expanding effects, in all directions, of major life losses.

Theresa is a friend of my cousin's, and at a dinner party several years ago we met and enjoyed one another's company, finding common interest in food and cooking. Beyond this project, we've exchanged recipes and enjoyed discussing food, cookbooks, and cooking techniques. (I have also worked as a cook, though on a smaller scale and with much less training and experience than Theresa.) ◆ At our first Women of Taste project lunch, I asked Theresa about her earliest memories of food preparation. Her answers provided a complete story as well as an emotional connection between us based on early deaths in both our families. ◆ Theresa's older brother died suddenly when she was ten, which, of course, has had a long-term effect on her family. Rather than take Theresa and her younger brother to the wake, her parents and older brothers left the children with a neighbor, who had Theresa spend the day making a carrot cake step-by-step, something she had never done before. Theresa was very proud of the cake, as was her mother when Theresa presented it to her. It was an emotional experience for both of them. As a teenager, Theresa did a lot of cooking at home, and her mother enjoyed the help. She and her mother were very close, and her mother died relatively young, shortly before Theresa's marriage. ◆ My own mother died when I was eight. After my conversation with Theresa, I remembered a day when I was six or seven and made my mother get up to make breakfast when she was ill because my father couldn't make eggs the way I liked them. I wanted things to be the way they were supposed to be. She wasn't supposed to be sick. After experiencing this recollection, I realized that I could probably make a timeline of my life through food memories. ◆ Theresa's and my stories are different, of course, but because we share the experience of early loss, we didn't have to explain the feelings or the fact that these losses continue to affect our lives, many years later. This created a real bond between us. Theresa's comment at the end of that lunch was to wonder how we could get death and carrot cake into the same quilt and yet not be too morbid about it, which was pretty much what I'd been thinking.

—REBECCA ROHRKASTE

REBECCA ROHRKASTE lives in Berkeley, California. In college, she studied fine art, focusing on fabric sculpture. She was introduced to traditional quiltmaking in 1977, and began quilting in earnest in the mid-1980s, learning from a variety of teachers. She has been a full-time studio quilter since 1991, making one-of-a-kind quilts for beds and walls. Her quilts are pieced reinterpretations of traditional designs and techniques with a painterly emphasis on color relationships.

THERESA ROWLAND is a private chef in Palo Alto, California. Though she has been cooking since childhood, she only turned to professional cooking after a liberal arts education and a foray into the magazine industry. She returned to school to attend the California Culinary Academy, and has since cooked in restaurants in New York, San Francisco, and Palo Alto. Now self-employed, she creates elegant, multi-course meals for small groups in private homes.

Photo: Sibila Savage

JANE A. SASSAMAN ◆ SARAH STEGNER

GLORIOUS GREENS

58 x 61 inches

Cotton fabrics. Machine appliquéd
and machine quilted.

Through her cooking, Sarah celebrates the living gifts of nature, for
when we eat we are eating the sunshine and the rain, touching the
hands that cultivate the fruit and entering into the heart of all life.
My quilt is also a celebration of the living gifts in nature. An enlarged
collection of lively and radiant growing greens emphasizes the life we
consume in order to live. This composition also gave me the perfect
excuse to include some giant cherry tomatoes with their stems,
one of Mother Nature's food designs I have always admired. The
elements are set against black, which gives life to color just as a
cloudy day makes flowers appear brighter.

Sarah and I were only able to meet a few times during this process since our working schedules are on the opposite ends of the clock. One evening, she treated my husband and me to her talent with what seemed like a twenty-course meal, in the elegant Dining Room restaurant of the Chicago Ritz-Carlton. Each course came with a new table setting and yet another wine. Naturally, we were grinning from ear to ear by the end of the evening. Because of Sarah's creativity every course was elegant and extraordinary. Each dish had sublime harmonies of flavor, texture, and smell. ◆ It was a unique experience for me to participate in the world of a woman so intimately connected with her sense of taste—especially for someone like myself who is totally content with a meal of steamed potatoes and zucchini, accented only with the basics: sour cream, fresh chives, butter, salt, and pepper. This is also the approximate level of my cooking skill. If it takes longer than thirty minutes to prepare, I'm not interested (I'd rather be quilting). Cooking is a necessity only because my family demands to eat. If no one mentioned it, I'd forget about it altogether. In my opinion, 365 dinners a year is way out of line! ◆ But Sarah is my total opposite, thank goodness. Her entire life revolves around her precise palate and its ability to distinguish subtle qualities and robust flavors and smells. She has developed relationships with the best specialty-produce growers in the Midwest, and consequently is supplied with a stunning variety of fresh ingredients. She spends her entire day in a huge kitchen directing her staff and creating her glorious menus, and in the evening, people gather in her dining room in anticipation of the quality and care they know has gone into their meal. Sarah transforms the simple necessity of eating into a joyful feast. ◆ In making the quilt, I drew inspiration from the raw materials Sarah uses. Over time, one finds one's own language, and long ago I found mine in nature. I think of Mother Nature as a metaphor, because everything that happens to a plant or tree also happens in our own lives—sprouting and growing, the seasons of the year, the seasons of life. Fiber artists from almost every culture have long depicted the tree of life in this vein. In celebrating these images and cycles, I prefer to emphasize the human spirit and the positive qualities of life. My work does not expose the warts of the world. I think we need both approaches, but I was not born to do the latter. I was born to celebrate our existence.

—JANE A. SASSAMAN

JANE A. SASSAMAN lives in Chicago. She never wanted to be anything but an artist, and studied textile design and jewelry in college. She worked as a window dresser, sign maker, illustrator, and designer of decorative accessories, all while continuing her personal painting and fiber projects— embroidery, soft sculpture, and costume making. When she began quilting, in 1980, she found that these "soft paintings" satisfied the draftsperson, craftsperson, and artist in her.

SARAH STEGNER is chef of the Dining Room, in the Chicago Ritz-Carlton. Her family has always been devoted to food, including a grandmother who was a caterer "before women did those kinds of things." The table was the center of the family, and Sarah's passion for food emerged there. In 1985, at the age of nineteen, after earning her chef's certificate, she started at the Ritz-Carlton as an apprentice cleaning fish. In 1990, she founded the Women Chefs of Chicago, which raises money for local charities.

JOAN SCHULZE ◆ ALICE MEDRICH

CHOCOLATE PAPERS

61 x 56 inches

Cotton fabrics. Printed via xerographic transfer, monoprinted (via PVA transfer) and hand painted. Metal leaf hand-applied with PVA glue. Machine pieced and machine quilted.

When Alice and I first met, she already had ideas for the quilt. She has a keen interest in design, and really wanted to be part of the working process. She talked about the many shades and values of chocolate, plus the variety of whites and creams, and she described how she enjoyed the sparkle of gold and silver in the chocolate wrappers. We decided that Alice would collect ephemera for our use in inspiring ideas and creating fabric, and we would collaborate on the printing. Not only did Alice actively think about the process and make great suggestions, also she kept us supplied with chocolate truffles throughout.

An abridged diary of *Chocolate Papers:*

AUGUST 26. Alice and her daughter arrive at my quilting studio with a small gold bag tied with narrow red silk ribbon. The bag contains enchanting melt-in-your-mouth chocolate balls rolled in cocoa. Alice has also brought two of her chocolate cookbooks, and we discuss ideas for the quilt. ◆ OCTOBER 23. In reading Alice's books, I have found similarities between the two of us—she doesn't stick to traditional techniques, is a passionate problem-solver, works with other crafts, and is not fussy or frilly but aspires to a clean, elegant, and simple aesthetic. I see that she uses the putty knife and spatula to make effects in the frosting—perhaps we can do some monoprinting on fabric using these tools. I make Alice's "Fallen Chocolate Torte" for a dinner party—easy and a huge success. ◆ DECEMBER 4. After meeting once again at Alice's to cook together and discuss ideas, we get together in my garage to make prints from all the papers and pictures she's given me. I have collaged them, made selections for printing, and readied them to transfer onto cloth, while Alice has brought another magical bag of truffles. We spend all day mixing browns, inking, and printing. The garage is filled with drying fabric. ◆ JANUARY 17. After coping with a disastrous reaction between new paper and old glue on all the fabric Alice and I printed, and working furiously to re-photocopy everything, I am back on track. I paint some of the transferred cloth—it's a risk, but I need to see color. I concentrate on gold and chocolate brown. I can't wait to get all the fabrics to my loft to see what I really have. The quilt is now called *Chocolate Papers.* ◆ JANUARY 22. Started in right away to make the "text/image" sections for the quilt. Very slow but fun work trying to make things come out right. Several interruptions but I didn't lose my train of thought. ◆ JANUARY 26. Finished the curved pieces. I will have to make samples of painted surfaces, as it must be just like frosting—I can see it in my mind and dreams. ◆ FEBRUARY 16. I begin printing the frosting part of the quilt. Mixed up a large batch of "chocolate" (paint). Needs to dry overnight because it's so thick. ◆ FEBRUARY 19. Briefly arranged the pieces so that I could think about it overnight. Finished the gold-leaf edge pieces. ◆ FEBRUARY 20. Worked all day laminating then sewing each segment. Slow and careful work. A very serene day. Enjoying the top as it gets more complete. Seamed the gold leaf on the left side of the quilt. I just want the idea of chocolate presentation. More would be too much. ◆ MARCH 1. I finish the quilt.

—JOAN SCHULZE

Quilt back

JOAN SCHULZE lives in Sunnyvale, California. She worked as a schoolteacher until deciding in 1970 to follow her lifelong dream of becoming an artist. Like pages in a journal, her artwork reflects what she sees. Her quilts are a collage of fiber techniques, ranging from printing to painting to transferring to paper laminating. She relates her work process to jazz improvisation, and often composes poems in conjunction with her artwork. She is the author of *The Art of Joan Schulze.*

ALICE MEDRICH is an author, pastry chef, and teacher living in Berkeley, California. During a year spent in Paris, she learned to make truffles from her old-world host, who no longer had servants or a chauffeur but continued to make truffles as gifts. In 1976, she founded Cocolat, a dessert and chocolate company in Berkeley, and thus was born the large-sized American chocolate truffle. She expanded Cocolat to seven stores before selling the company in 1990. Her most recent book is *Alice Medrich's Cookies and Brownies.*

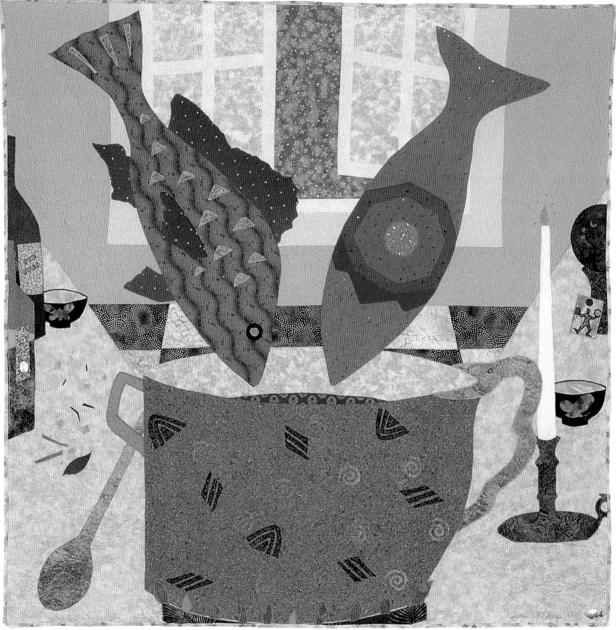

KATHLEEN SHARP ◆ SUSAN H. SPICER

FISHSTEW

48 x 48 inches

Cotton, cotton-rayon, and silk metal fabrics, glass beads, St. Expeditus charm from New Orleans, and silver fish commissioned from Navajo artist Don Nelson. Hand stamped with paint. Machine appliquéd, machine pieced, machine quilted, machine embroidered, and hand embellished.

During a visit to New Orleans, I met Susan, toured her world, and took some photographs. My idea was that together we create our own "fish stew" (I like fish images and have worked with them before), perhaps served up in a setting and palette inspired by her restaurant. Susan's favorite fish visually is the red snapper, a fish that one could also actually *eat*. On the other hand, my favorite fish is an imagined icon, myth-laden and cosmic-eyed. Pondering this difference became the starting point for this quilt. Finally, I included a juggler because it is under this influence that both Susan and I were working at the time—the gift of the juggler is grace.

n my quilts, I am particularly interested in creating the illusion of architectural space. I depict settings and senses of places in which viewers might wander and wonder at will. I don't fill the spaces, because it's important to give viewers the room to bring what they will to the work. A number of my quilts are theaters and design sets, usually with some imaginary performance in mind. I began creating the illusion of three-dimensional space in my quilts because I *had* to imply volume. Architectural elements are basic to my vocabulary and endlessly fascinating. Myth and symbol also draw my attention. Symbolic fish are the only food-related elements I've ever before incorporated into my work. I had never thought of putting more literal food images into a piece. ◆ When I quilt, I often think about what might happen in a particular imagined space. This carries me through the labor-intensive process of trying to manifest ideas into a quilt, and through dealing with the fact that I spend my adult life cutting up fabric and sewing it back together again in a culture that thoroughly demeans such labor. My absolute love for this medium is based on its simplicity, populist appeal, tactile qualities, reliance on found items (fabric), large format, and long tradition of honoring what any one woman finds important and interesting. I feel very, very free, bound only by my imagination. ◆ Over the course of this project, I thought about the many similarities between what Susan and I do. The concept that wouldn't let go of me is that both the chef and the artist work to "feed" humanity, each in her own way. In her work with food, Susan is a chef, purveyor, and educator. Through our different disciplines, we each engage in a creative process of gathering, transforming, and feeding or offering. Part of that work is intuitive, unspoken, sensed, arising from complex connections and layers of consciousness—for Susan, I thought of this as a "taste, taste, taste" mantra, and for me I imagined a "wonder, seek, wonder" mantra. Another part of our work is the practical manipulation and use of raw materials and resources in the here-and-now. While these aspects are weighted differently for us, with culinary art leaning toward the concrete (hence the edible red snapper) and visual art leaning toward the abstract (hence the dreamy icon fish), both tendencies are critically important to both disciplines.

—KATHLEEN SHARP

KATHLEEN SHARP lives in Monte Sereno, California. After concentrating on a career in community mental health, all the while creating and studying art in different forms, in 1977 she decided to become a full-time studio artist and gave herself one year to determine what her medium would be. Instantly the desire to make a quilt popped into her head. She did not know how to sew, but took courses in basic technique and history, and has been quilting ever since.

SUSAN H. SPICER is chef and owner of Bayona, in New Orleans. The sixth of seven children, Susan grew up watching her Danish, South America–raised mother cook internationally influenced dishes for the well-traveled military family. Susan first worked in printing but when she got a job in a restaurant everything clicked. After study, travel, and more restaurant work, in 1990 she opened Bayona, followed in 1997 by Spice, Inc., a cooking school, takeout, and specialty-food business.

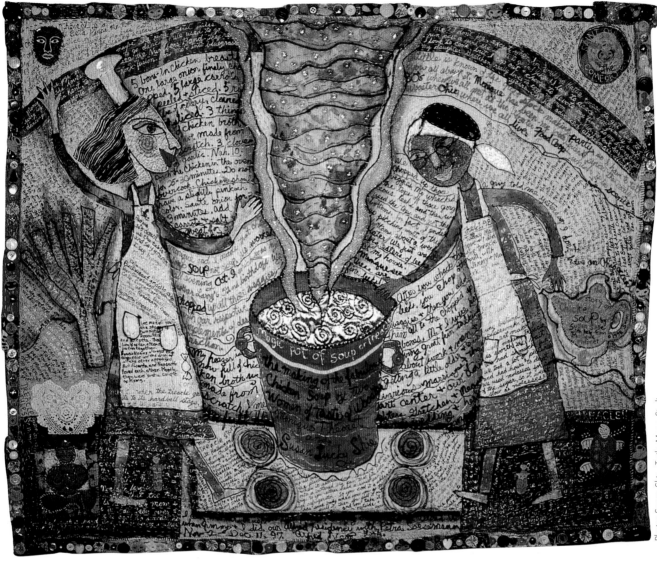

SUSAN SHIE ◆ MONIQUE THÉORÊT

TREACLE SOUP

63 x 51 inches

Various fabrics, polymer-clay charms, glass and plastic beads, buttons, handmade ceramic figures, plastic trinkets, doily, Hmong-embroidered turtle, and floral marbles. Hand painted, airbrushed, and inscribed. Hand appliquéd, hand pieced, hand quilted, hand embroidered, and hand embellished.

Who could ask for more than to work with Monique, who loves to cook and has been a good friend of mine since the early 1980s? We decided our interaction would be cooking together in my kitchen. The quilt is a picture of what the cooking scene felt like: a big bubbling pot on the stove, with us dancing around it, chopping food and talking. Big whorls of steam rise up with our laughter! The stream-of-consciousness writing on the quilt reflects the conversation. Monique wears the cliché big chef hat, and I got the proverbial black beret of the artist.

When Monique asked me what I'd like to learn to cook, I chose chicken soup from scratch. She made a chef's house call and taught me how to make a really wonderful stock (two ways: the slow, simmering way, and the quick and dirty, yet kind-of-gourmet way), and with that a great chicken soup. Her enthusiasm is so contagious! We worked playfully, and also quite seriously, for three hours. Since I persuaded her to take a bowl's worth home, I know she considered our end product worthy of her picky "Foody" standards (a Foody, says Monique, is someone who's a food snob and can talk on and on about her favorite foods and the *only* way to prepare them). ◆ So I started the quilt, thinking it would be called *Chicken Soup.* Monique came over again to write on the quilt, but then I asked her to tell me a food story from her childhood in Quebec. She spun an enchanting tale of making treacle, a pulled molasses taffy. I was so charmed, I begged her to teach me how to make that! So we made treacle. I finished the quilt and knew the title had to change to somehow include the marvelous experience of pulling the treacle. ◆ Now the piece is renamed *Treacle Soup,* and nobody will say, "Huh? Like the books on chicken soup?" There is no such thing as treacle soup, except you could call the goop that eventually becomes the treacle "soup" while it's slowly boiling down to the hard-ball stage! (With molasses, it takes *forever!*) We sure had fun waiting, though! You know, you mustn't stir it very much, even though it's boiling, or the sugar will crystallize, and then what are you going to do? No use crying over crystallized treacle, I always say! ◆ I threw lots of stuff into the quilt to keep us company while dancing around the pot. Of course, there's all our writing, which we both put directly onto the quilt with no idea of what we were going to write until we did it—I like that suspense. There's a baby Jesus, from our Mardi Gras King Cake, sewn into the pocket of my apron. Purple Mardi Gras beads adorn the giant red soup pot. And little tiny pieces of silverware float around the writing, to mean "Hey, let's eat already!" The little head in the top right corner (and some in the border, along with the teacups and hearts) is Saint Quilta the Comforter, the patron saint of quilters, who came to me once in a rapture. Saint Quilta definitely hung around the kitchen while Monique and I were cooking our *Treacle Soup.*

—SUSAN SHIE

SUSAN SHIE lives in Wooster, Ohio. Since 1989 she has primarily collaborated with her husband, James Acord. They call their improvisational, mixed-media quilts *vey veys,* which in the Voodoo tradition are objects that contain spirit and soul. Susan founded the "Green Quilt" project, which exhibits and maintains an ever-growing registry of over one thousand quilts with messages of healing. Susan and her husband teach workshops around the world, and hold "Turtle Art Camps" in their home. Susan's nickname is "Lucky."

MONIQUE THÉORÊT lives in Wooster, Ohio. Cooking has always been her passion and creative outlet, and she has worked in many restaurants and run her own catering company. As a single parent, Monique decided to pursue other work because restaurant hours conflicted with her daughter's schedule. She is currently an arts-center administrator and has co-founded the Uncommon Gardener to sell her vinegars, bring to market the heirloom organic produce grown at her partner's farm, and to distribute her own recipes.

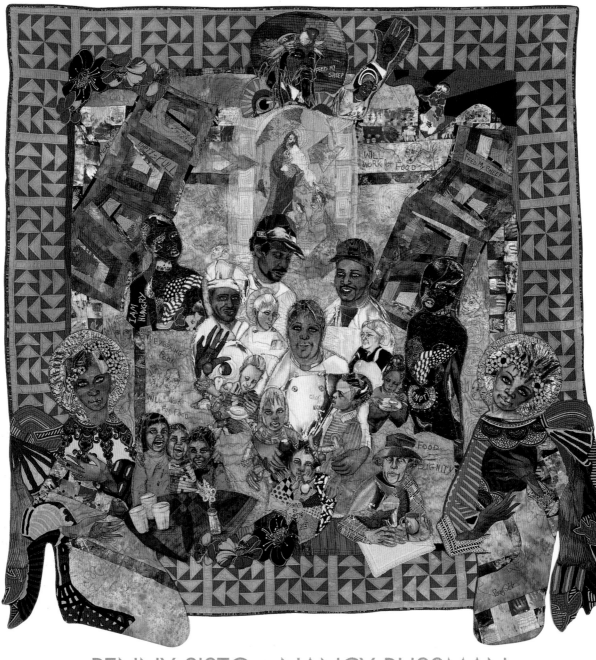

Photo: Sibila Savage

PENNY SISTO ◆ NANCY RUSSMAN

**CHEF NANCY AND THE FOOD ANGELS
AT THE OPEN HAND KITCHEN**

100 x 102 inches
Linen, cotton, and silk fabrics, and a mola.
Hand dyed, drawn, and painted.
Hand and machine appliquéd, machine pieced,
hand and machine quilted, and hand embroidered.

Nancy, this woman, this chef, this tiny dynamo, cooks up more than food in her community kitchen. She tosses in pride, compassion, discipline, and more than a little love. Every time I visited the kitchen, I met another kitchen assistant or customer and heard another story, so I wanted the quilt to be a group portrait, to include Nancy's food angels and their prayers for food, as well as the homeless and working poor—men, women, children—whom they serve, with Nancy as the linchpin, front and center. I also included the kitchen's stained-glass windows. Religious icons and American flags represent the hunger that exists in this country, which St. Vincent's is doing something about.

How to describe Chef Nancy? She's like a walking tidal wave. She sweeps across the kitchen, and a huge skillet the size of a bathtub gets the once-over: "Hey, what's that in there?" We all look inside as Nancy pokes at the anonymous ground meat. "It's venison," she finally decides. "We get a lot of deer meat. That's one reason why I love this job. You never know what you've got to work with from day to day—which makes it *real* creative! One day," Nancy continues, "we were short of milk. Jarvis, who is going to be a deacon, got to praying for it." Jarvis, an immense gentle giant made even taller with the addition of his two-foot-high toque, nods in agreement. Nancy laughs a deep and throaty guffaw: "By the end of the day, I had to order him to stop praying—we were swimming in milk." ◈ Nancy stands about five feet tall, and wears a spotless white jacket over a pair of Looney Tunes pants. "The kids love them," she explains. Her eyes are always moving, watching, alert. She *rules* the Open Hand Kitchen. "I refuse to call it a soup kitchen," she says. "It's a community kitchen. We feed our community: the homeless, the hurt, the working poor." Nancy was once a chef at one of the best restaurants in Kentucky. She ran her own restaurant for a while, and was much in demand. Then one day she chucked it all for the Open Hand Kitchen. The kitchen serves over 100,000 meals per year—no one is turned away. Nancy says, "The reward of serving my hungry guests is that I look in their eyes and see that they are no longer hungry today." ◈ Nancy's special baby is Cooking Up a Future, a culinary-arts job training program which consists of a rigorous six-week course in basic kitchen and job-seeking skills. All the staff at the Open Hand Kitchen are working their way up from the street. In the dining room, there's a vase of flowers on every table. I speak to a young man in a wheelchair who has no legs. As he tells me his story, Nancy walks over: "Time to set out the silverware, Bud." She turns to me. "He has a job here and he does it well, too." ◈ I finish the quilt and bring it to the kitchen. On a busy, hot day during lunch hour, at least a hundred folks cluster with trays in hand. They line up not for food but to see their quilt. One woman, sweat rolling down her face, has walked four miles—her sister called her to tell her she was on the quilt. An elderly man thanks me—and Girls Incorporated—for the opportunity to tell the story of their kitchen, their lives, and their focus. I am stunned by the reception they give me. Those who have so little give so much.

—PENNY SISTO

PENNY SISTO lives in Floyd Knobs, Indiana. Born in the Orkney Islands, she had little formal education, though her grandmother taught her to read and sew. While running health clinics in Kenya, she combined the needlework of her childhood with the crafts and aesthetics she learned from the Masai tribe. As a midwife, she has helped to birth over 2,500 babies. She has worked as a dairy farmer and raised nine children. She is the subject of a documentary, *Woman of the Cloth.*

NANCY RUSSMAN is executive chef of the Open Hand Kitchen of the Society of St. Vincent de Paul, in Louisville, Kentucky. She began cooking by apprenticing in Louisville restaurants and worked in several, as well as owned her own before opting to head up the Open Hand Kitchen and training program. She also teaches culinary arts at a local community college as well as lecturing at conferences about hunger and food distribution.

PETRA SOESEMANN ◆ JEANNINE SNYDER

SKETCHBOOK

39 x 53 inches

Silk, cotton, and synthetic fabrics. Hand marbled.
Hand and machine appliquéd, machine pieced,
and hand and machine quilted.

I drew my ideas for *Sketchbook* from a late-night cooking collaboration at the restaurant where Jeannine worked. These inspirations included the incredible magenta-red color of the beet pasta we made together. The pasta-making process reminded me of the marbling process, which involves edible substances and is a lot like cooking. I also referenced the tarot card "Temperance," which is about magical formulas and the transmutation that occurs from mixing substances together. The card often represents cooks, artists, inventors, and creative transformation. Because both creative cooking and artmaking involve experimentation, and because the individual squares of the quilt are like pages from a journal, I called the quilt *Sketchbook*, suggesting spontaneity, discovery, and beginnings rather than endings.

When Petra invited me to participate in this collaboration, she suggested that we cook a dinner together, then she made two menu requests: first, she asked that I use liquids, preferably emphasizing deep and vibrant shades of red, and second, she hoped that I might incorporate a marbling effect or swirling of ingredients. The kitchen at Coccia House, the restaurant where I worked, afforded us the space and equipment necessary for any menu I could dream up. In remaining true to our restaurant's reputation as an old-world, family-run business in operation for forty years, and as a salute to the owners' (the Calabria family) Italian roots, I settled on braised lamb shanks in Chianti wine with baby root vegetables served with two flavors of fettucine—beet and fresh mint with rosemary. After closing time and a round of cappuccinos and cognacs one Saturday night, our cooking adventures began. The stock-and-wine-based sauce for the lamb shanks gave Petra a good example of the texture, viscosity, and depth that sauces can have, and provided a deep red color. Karen Calabria demonstrated the proper pasta-making techniques that only years of experience can teach, and we made the fettucine the old-fashioned way: by hand, on the table, with a hand-cranked pasta roller. My hope in doing it like this was that Petra could see the coming together of ingredients to form something new. The colors were wonderful and the textures and fragrances outstanding! The fresh-mint-and-rosemary fettucine had a seeming double layer with a subtle swirl of colors, while with the beet fettucine we may have created a new shade of magenta (at least for the kitchen!). As the evening came to a close and we were about to toast the results of our efforts, someone pointed out that it was 5:00 A.M.! We did the only logical thing: we uncorked a nice Italian red wine and toasted our breakfast.

—JEANNINE SNYDER

Lately I've become interested in producing and designing my own fabric, and this project seemed like a good opportunity to explore marbling. At the time, I had a lot of red fabric, so I thought Jeannine and I could collaborate on something red. That led us to discussing the color in all its variations, and foods like wines, wine sauces, and beets, which I love. After our evening of cooking, I started experimenting with marbling, trying different pigments, colors and so forth. Just as with the pasta-making, I never know what I am going to get! After creating all these swirls of colors, I decided I needed a more neutral background to set them off and didn't actually use any red fabric. The real fun, after the marbling, was in playing with the pieces and seeing what kinds of images and shapes the patterns suggested.

—PETRA SOESEMANN

PETRA SOESEMANN lives in Cleveland, Ohio. Her mother is an expert seamstress and taught her not only how to sew, but also to have confidence in her problem-solving abilities. She has studied landscape architecture, sculpture, painting, and textile design, and is the chairperson of the foundations department at the Cleveland Institute of Art. She has studied Incan and Mayan architecture, published limited-edition artists' books, and founded the "Up in the Air" UFO Quilt Invitational.

JEANNINE SNYDER is chef and manager of Café Carmen, in Wooster, Ohio. Her mother and grandmother were both accomplished home cooks, and Jeannine grew up cooking. In 1984, she was in need of a job, and was hired at a restaurant. She showed talent, and her first boss encouraged her to push herself. She has since worked her way through the ranks—and Midwestern preconceptions about women in the kitchen—at assorted restaurants as well as earning her certification as chef de cuisine.

NANCY TAYLOR ◆ WENDY BRUCKER

QUARTET

57 x 57 inches

Cotton fabrics. Screen printed.
Hand appliquéd, machine pieced, and
machine quilted.

This quilt evolved from my experiences of Wendy and her restaurant, Rivoli. The center background, partial views of fruit and vegetables arranged in neat rows, refers to both the inspiration for Wendy's cuisine and to her love of order in the kitchen. The four floating collages represent the garden bounty of the four seasons. The text is taken directly from Rivoli's menus, and the flatware and goblets are a reminder of the celebratory feeling that a meal there evokes. Color inspiration comes directly from Rivoli, indoors and out. The two fragments of female faces refer to the fact that the Women of Taste project was created by interactions among women—quilters, chefs, and Girls Incorporated.

My husband I have been fans of Wendy's restaurant, Rivoli, since our first visit almost five years ago, not long after it opened. The fact that we drive forty miles to get there is an indication of our enthusiasm. When this project was proposed, genie (and project organizer) Lynn Richards was able to grant my wish to work with Wendy. ◆ I had initially thought I might create a portrait of Wendy, especially because women and their work have gone largely unportrayed for so many centuries. After meeting Wendy and discovering how outgoing, animated, energized, and delightfully visible she already was, a change in focus was necessary. Instead I depicted my experiences of her restaurant and food. ◆ Now I had justification for driving to Berkeley to do edible and conversational research, and made the trip several times over the course of the project. I learned that the starting point for Wendy's menu, which changes every three weeks, is fresh produce. She uses the freshest vegetables, fruits, and herbs in season, and with these in mind "designs" her way toward the fish, poultry, or meat the dishes will ultimately include. Wendy sent me a year's worth of Rivoli menus, and reading these was a wonderful way to see the gradual flow of the seasons through the changing foods. ◆ Wendy's approach to cooking is very different from the 1950s Midwestern diet of my childhood, in which meat was always the starting point and produce freshness was not a primary consideration or even sometimes a possibility. Since moving to California, my own cooking has come to reflect the availability of fresh, local produce as well as the influence of meals at restaurants such as Rivoli. This project has also led my quilting in new directions. *Quartet* was my first quilt with imagery created entirely via screen printing. I drew some of the screened images myself, and gathered others from clip-art books. This quilt's color palette is not typical of my other work, but directly reflects the fresh produce found on Rivoli's menu and echoes the restaurant's interior and exterior colors. ◆ Sometimes you go into a restaurant, experience the food, and immediately sense a distinctive presence behind the tastes and aromas. As in the book and movie *Like Water for Chocolate*, food can become a means of communication between chef and diner. Wendy's ability to express herself through the complex manipulation of flavor relationships is a joy for me when I dine at Rivoli.

—NANCY TAYLOR

NANCY TAYLOR lives in Pleasanton, California. She majored in art and design in college, and made her first quilt, in 1975, from her young daughter's favorite outgrown dresses. Her mother, also a neophyte, encouraged Nancy by offering to hand-quilt it, the first of many such collaborations. Tired of long drives to buy materials, she opened a quilting shop and gathering place, Going to Pieces, in 1980. She is also a consultant for P&B Textiles.

WENDY BRUCKER is chef and co-owner of Rivoli, in Berkeley, California. She grew up in Berkeley but spent many childhood summers in Italy and France, receiving an informal education in art, history, and food. In Berkeley, her palate was influenced during family celebrations at Chez Panisse. After attending culinary school and cooking and studying management in top Bay Area and Los Angeles restaurants, in 1994 Wendy opened Rivoli with her husband, Roscoe Skipper.

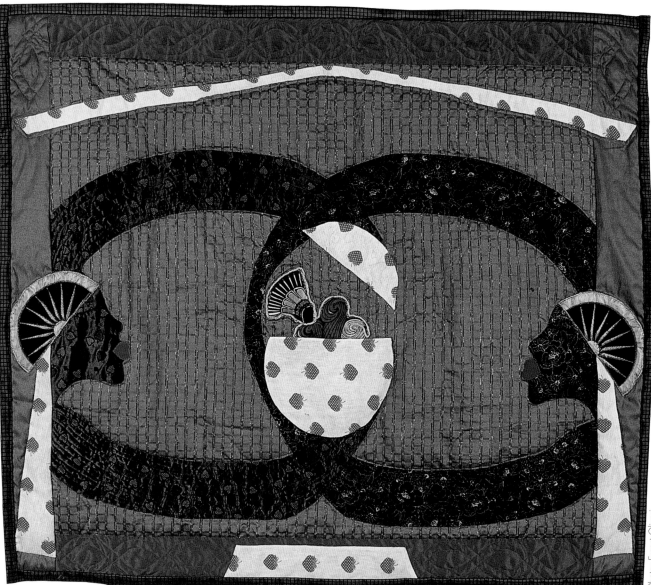

ARZU TITUS ◆ NORMA JEAN DARDEN

UNDER THE APRON STRINGS

60 x 60 inches

Cotton, rayon, and silk fabrics, suede, Murano glass beads, and dyed banana leaves. Images photo transferred. Hand painted. Hand appliquéd, hand pieced, machine quilted, machine embroidered, and hand embellished.

I have long been a great admirer of Norma, who is very big in New York. Everybody loves her cooking. I'd hoped Norma might give me a special piece of fabric, and when she blessed the project with her lucky apron, I was truly honored. It was as if a famous ballerina had given me her first and favorite pair of ballet slippers. The strawberry-adorned material was beautiful, and its colors were perfect for the rest of the piece—my only challenge was to incorporate it into the quilt. I created images of two women, Norma and myself, exchanging and offering, one woman giving, the other receiving.

My work is about the evolution of women, who are the givers of life and love. In our many roles as friends and lovers, mothers and sisters, we laugh, cry, contemplate, support, suffer, struggle, and, through all of this, we continually develop and grow. All of my pictorial quilts are freeze-frames that capture the moments when this evolutionary process actually occurs. The prevalent theme throughout my work is women discovering the dignity in their lives as they undergo the experiences of seeking, loving, losing, and winning. In many ways, my quilts reflect my own spiritual path and evolution as a woman. My style is a collaboration between my creative energy and the inherent will of the fabric. The results are pieces that emit life beyond what the untouched fabric could do by itself.

—ARZU TITUS

I loved getting to know Arzu. She is wonderfully unusual and spiritual and deeply rooted in her art. She came to see me in my kitchen just after I'd opened my restaurant, and provided me with such calm moments. My own favorite part of the collaboration was having a female friend drop by to watch what I do—I found that very reassuring. I wondered how she would design a quilt about us, and then her eyes lighted on my strawberry apron. I thought it would just inspire her, but it became part of the quilt! She said the apron represented the ties that linked me to her and to the community. I thought that was so beautiful. ◆ I love the whole feeling of quilting; it just seems to calm you and take you to a past tense, another century. I grew up making things and watching others sew: my grandmother was a seamstress in North Carolina, and my cousin was a home economics teacher. Quilts are such a loving endeavor, because they keep the body and the soul warm. Now, of course, they've become objects of art in themselves, so they're keeping soul, body, and spirit alive and warm. As a quilt comforts, the dishes I cook are comfort food—so with this project we have comfort for both the outside and the inside of the body.

—NORMA JEAN DARDEN

ARZU TITUS recently moved back to Central America. She immigrated to New York City from Honduras in 1967, and established a career as a law librarian, designer of law libraries, and lecturer. She began to quilt in 1993, when a friend told her he had AIDS. She decided she must make him a quilt, so other friends gave her fabric and how-to books, and her mother talked her through it. While creating that quilt, she realized she had to become a full-time artist.

NORMA JEAN DARDEN is chef and owner of Spoonbread Inc., a catering company, and the restaurant Miss Mamie's Spoonbread Too, in New York City. Raised in North Carolina, she has found success as a model, actress, magazine writer, and playwright. She founded her catering business after publishing a cookbook and family history, *Spoonbread and Strawberry Wine* with her sister. She opened her restaurant to provide a community gathering place after people began stopping by Spoonbread Inc. to see if they could dine there.

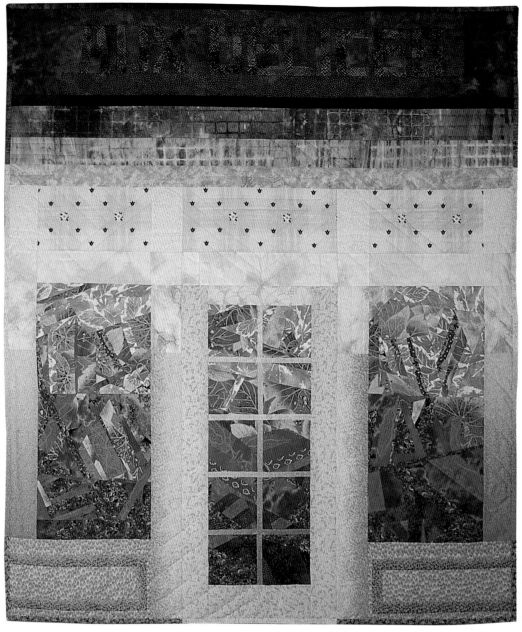

Photo: Judi Warren

JUDI WARREN ◆ DEBRA PONZEK

AUX DÉLICES

49 x 57 inches

Cotton fabrics. Machine pieced and hand quilted.

Through letters and telephone conversations Debra and I discovered that we are attracted to a similar color palette. We also determined that "Judi doesn't cook and Debra doesn't sew." From pictures, I was fascinated by the architectural symmetry of the building that houses Aux Délices, (which means "all the wonderful things in life"). Although "our" quilt is partially pictorial in nature, it is not completely so: the view through the windows reveals not interior elements, but instead the lavender fields of Provence depicted in multi-fabric, abstract crazy piecing—Provence in Connecticut.

Dear Debra,

I hope that you are not very good at sewing, because I am *really* not good at cooking. I'm looking forward to working with you on this project! I must tell you that I have never worked "with" someone to make a quilt before—and all my work is quite personal and inspired by fond memories and favorite places. Interestingly, among my previous pieces are several that were inspired by food. ◆ At this point, I have no idea what direction the piece will take, so a few questions: What kinds of quilts do you enjoy? What kinds of colors? Do you envision "our" quilt as folksy or elegant? Semi-pictorial or geometric/abstract? What are your favorite things to cook/eat? (Mine are fresh raspberries and peaches. See? No cooking involved.) What is your favorite aspect of your work? What is your favorite menu? ◆ Did you like the movie *Big Night?* I loved it. *I didn't* love *How to Make an American Quilt.* I hope this will be fun for you—and that we'll come up with a beautiful quilt together!

—JUDI WARREN

Dear Judi,

What we're doing at Aux Délices is a relatively new venture for me. My background has been cooking food (French) in restaurants for about fourteen years. My husband and I opened Aux Délices two years ago, and we do gourmet takeout food—restaurant-quality food for people to bring home—and quite a bit of catering. ◆ I think the slides of your work are beautiful. I was so impressed. And since you conceded that you don't cook, you should know that my idea of sewing doesn't go beyond a needle, thread, and button. ◆ As far as colors, I enjoy those of Provence—lavender and pale yellows. I love copper and terra cotta colors and creams and ivory. I guess I see the quilt as something elegant—I don't see perfectly stitched, colored, and outlined pictures of fruit and vegetables. Perhaps something more subtle, delicate, maybe only in a few colors. It's probably easier to talk about the look of it over the phone—plus, after you get more pictures and information from me, I know you'll have lots of ideas.

—DEBRA PONZEK

JUDI WARREN lives in Maumee, Ohio. She earned her undergraduate degree in art education and an MFA in printmaking, and textiles, and has worked as an art instructor. Her great-grandmother and grandmother quilted, but she thought she'd become a painter instead, and created paintings based on quilts. One day in the mid-1970s, her grandmother saw her painting a nine-block pattern and said, "If you like them so much, why don't you make a real one?"

DEBRA PONZEK is chef and co-owner of Aux Délices, a gourmet takeout food and catering business in Riverside, Connecticut. She grew up cooking with her mother, who had studied French cooking, and her grandmother, who made traditional Polish dishes. She left a biomedical-engineering program to study at the Culinary Institute of America; travel in France further developed her tastes. She was chef at Montrachet, in New York City, until departing to write a cookbook, *French Food American Accent*, and open Aux Délices.

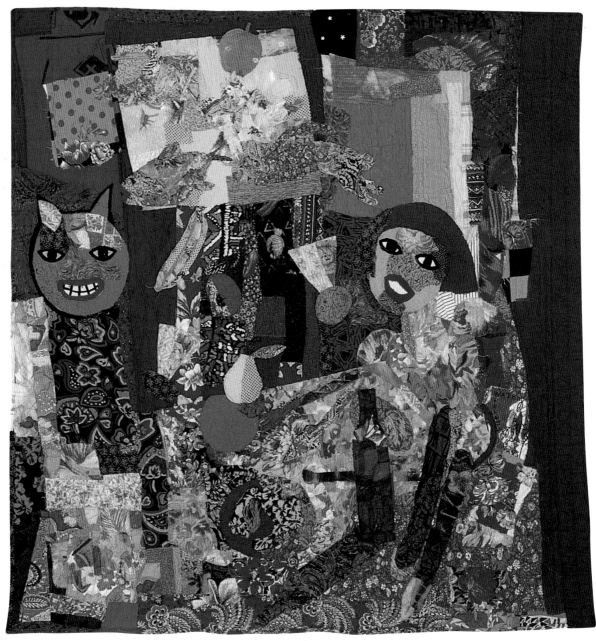

Photo: Sibila Savage

LIBBY CHANEY WASZINK ◆
MARY SUE MILLIKEN & SUSAN FENIGER

LUNCH AT BORDER GRILL

48 x 50 inches

Cotton, rayon, and polyester fabrics, including recycled clothing from Goodwill bins. Machine appliquéd and machine quilted.

I began the quilt by laying out some color and shapes from what I knew about Border Grill and brought these beginnings in for Mary Sue and Susan to see. After I gave them some fabric to play with, they returned it cut into the shapes of cooking utensils, a rabbit, fruit, wine bottles, and a house. Mary Sue also included pieces of her own towels. They were skeptical about what they'd made but said they knew I would "work my magic on it." I sent pictures as I progressed, and Mary Sue and Susan were enthusiastic and cheered me on.

When I received my chef match, I realized I had been hooked up with some pretty famous chefs. It turned out that their first restaurant, City Café, had been one of my favorites when I lived in Los Angeles! I was thrilled and intimidated. I wrote a letter to them introducing myself:

> I am an artist, and have always made things from cloth. When my son was in kindergarten, about nine years ago, I began to make quilts. They became my art form. I am so happy making quilts. They do not look traditional, but they can have the traditional function of bedcovers. I like to blend a huge variety of fabrics together. I launder them as part of the process to give the fabrics a worn look but especially to sort of meld the pieces together. I usually do not use imagery, so color plays a big part. Most of the shapes I use are natural looking, as opposed to hard or mechanical shapes. I am eager to show you my quilts. I hope you like them. I know I like your food! This is sort of a blind date we have!

◆ When I met Mary Sue, we talked for a while about the nature of her long collaboration with Susan. I learned that their recipes are based on mixing flavors with integrity, not in presenting a particular look. There is a certain similarity between their approach to cooking and mine to quiltmaking. My desire is to blend the fabrics together, and this blending has led to the look of my quilts. In other words, I do not generally have an image in mind that I set out to produce, but rather I have a way of working that influences the quilts I make. ◆ My quilts are usually abstract, so it was a struggle to work with the figurative shapes they made. But I found I was able to work in the way I usually do by juggling their imagery. The image that evolved was a cat lunching with a woman at Border Grill. The two characters have the same black outlines around their heads as the graphics on the Border Grill walls, as if they had come down for lunch. The shock of working with foreign shapes and trying to make the quilt "say" something seemed almost overwhelming at times, but I am happy with the quilt and there are ideas in it that I want to use in future work.

—LIBBY CHANEY WASZINK

LIBBY CHANEY WASZINK lives in Mill Valley, California. She earned a BFA and has worked in painting, drawing, and printmaking. She learned to sew in home economics and has always made clothing for herself, but she did not think sewing and art could be united until 1989, when she decided to make quilting her art form. She puts a lot of time into her quilts, and when she looks at them, they give it all back.

MARY SUE MILLIKEN & SUSAN FENIGER own Border Grill, in Santa Monica, California. Mary Sue was told she was too pretty for her first restaurant job, but campaigned the owner until he relented; she worked out so well that he eventually hired a second woman, Susan, and the two met. During culinary studies in France they dreamed about owning their own restaurant, and in 1991 opened City Café. Since then, as partners they have owned and operated City Restaurant, Border Grill, and Ciudad. The two host a television series and have authored four cookbooks.

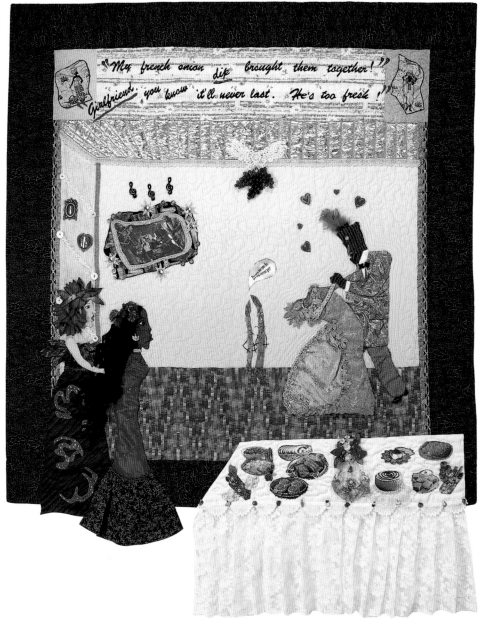

Photo: Sibila Savage

SHERRY WHETSTONE-McCALL ◆ SHARON GRIMES

YOUR PLATE OR MINE

56 x 58 inches

Cotton, brocade, lamé, and satin fabrics, lace, beads, silk flowers, synthetic hair, feathers, snaps, and buttons. Images photo-transferred. Hand appliquéd, machine pieced, machine quilted, and hand embellished.

Since Sharon and I were already close friends, we turned our attentions to the project itself. Our only objective was to have fun with the piece! I envisioned two vegetables at a catered event who escape from the table for just long enough to enjoy their moment of love. Both the artist and the caterer would be standing nearby, observing how their work brought these two together. The emphasis would be on the dip as matchmaker, and Sharon suggested another idea for "dip"—that the two should be dancing, with the carrot "dipping" the celery!

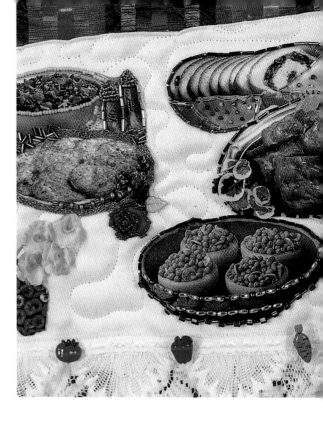

My energy for creating textile art began when I was released from my mother's womb. I have sewed all my life, but it wasn't until 1992 that I really began my art career, moving beyond doll clothes to wall pieces, dolls, and wearable art. Sharon and I became co-workers and friends eleven years ago, and she has been one of my biggest boosters ever since. She attends all my shows, and even catered the reception for my first public exhibition. I gave her one of my pieces, *Reaching for Heaven*, some years ago. ◆ After we established the narrative for this piece and brainstormed about its particular elements—the dance, the stage, the reception table—Sharon drew a sketch to illustrate her idea for the overhang of the tablecloth (overhangs are a signature of my quilts). As I left to look for fabric, Sharon worked on wording and font styles for the "conversation." She also compiled a list of title possibilities. ◆ The pressure was on after we'd decided on language and font, and I updated Sharon on my progress throughout. Sharon began taking photographs of some of her actual food creations, especially dips; I illustrated her raspberry-jalapeño cream-cheese creation, one of the offerings on the table. I thought about presenting myself in the piece as a potato, but Sharon was horrified! She said, "One look at you, and everyone knows you would never be anything as bland as a potato." She envisioned me as more of a hot and spicy red pepper, and so I am! Sharon was thrilled to be represented as a beautiful purple eggplant. She found the hairstyles on both figures especially interesting—she was a little envious of my "Diana Ross" hair, as she calls it, but the flower petals used to depict the eggplant's hair closely resemble Sharon's cropped red hair! ◆ I love experimenting with various fabric textures, color variations, and subject matter. What I find most challenging is coming up with new ways to do old things, but while creating my pieces, a deep spiritual karma is always present. Sometimes the fabric will actually speak to me and direct my actions. If I listen and allow my inner self to be embraced, I am overwhelmed with the end result of this magic. I want people to feel as if they can walk right into my creations—my world—and be a part of them. ◆ As Sharon and I mandated, we had great fun with this piece. We both agree that it came together in a wonderful way!

—SHERRY WHETSTONE-McCALL

SHERRY WHETSTONE-McCALL lives in Kansas City, Missouri. She works by day as the aging-services coordinator for the city of Liberty, and creates her art during off-hours. The idea of becoming a fiber artist was subconsciously planted in her head in 1978 while working in an African art shop in Germany. In 1992, she made her first piece. Except for a few classes, she is self-taught, free of inhibitions. She has a great desire to inspire and educate through her work.

SHARON GRIMES is chef and owner of Smiles by Sharon, a catering company, in Liberty, Missouri. As a child, she was known for her cake experiments and for her ability to entertain. She began working for the city of Liberty in 1987, and gravitated to a post as the city's special-events coordinator, which she still holds. With all she learned from the caterers and others who help with city events, she started Smiles by Sharon, which caters only for friends and family—and only for free.

ANGIE DAWSON WOOLMAN ◆ NICOLE PLUE

WITH DESSERT SYMPATHY

57 x 60 inches

Cotton, silk, and velvet fabrics.
Rubber-stamped by hand. Machine pieced
and machine quilted.

Though we met only briefly, I felt a strong connection to Nicole: when we shared a breakfast and conversed; when she treated me to eight desserts (which I ate in one sitting, I might add) at Hawthorne Lane, the San Francisco restaurant where she worked; and when she attended one of my quilt shows. I made *With Dessert Sympathy* from our individual experiences of restaurants (I have worked as a waitress) and from my memories of her amazing desserts. Her creations yielded fantastic flavors of design and taste, the visual blending with the tactile into a wonderfully decadent experience. The quilt abstractly represents a layered dessert, and also depicts different aspects of restaurants and cooking.

Though Nicole and I work in different arenas, our disciplines do have some elements in common. Of course there is the domestic quality of sewing and baking, but more importantly, the fruits of our two labors are presented first for visual impact and then second for a more tactile sense. After seeing eight of Nicole's desserts, I can generalize that our aesthetic senses both include bold, contemporary design, subtlety of texture, and versatile use of color. ◆ As a waitress, I saw firsthand the sexism of the restaurant kitchen, but Nicole seems to be at the top of the league. She did mention that the men who work for her are much more willing to try anything, while the women often question themselves. I had also, in my waitressing, been struck by the dichotomy between the elegant dining room and the hot, frenzied atmosphere of the kitchen backstage. When my daughter and I forged our way back to see Nicole at work on a Saturday evening after our lovely dinner, I was aware that she had been experiencing something very different. She took care not to hug me too close because I was all dressed up and she was sweaty and covered with flour. ◆ The layers of the quilt reflect these experiences, as well as the kind of luscious layered dessert Nicole makes. Overall, the quilt is structured like an eclair. The top and bottom are the chocolate layers. The top represents chocolate bars—the ingredients—and the cakelike bottom is patterned after a finished dessert. Second from the bottom is the word layer, the dialogue that exists in both the "plated" and "quilted" worlds—words of construction, recipes remembered and invented, reminders that timing is crucial, crazy-quilted dialogue of who this is for and whether it is right, swear words when what you're making is wrong and late *and* memory fails. Next up is the soft, wavy fruit layer, the yummy, pastel concoction often found in the center of desserts. The metallic layer above alludes to the antiseptic, rigid, steamy shininess of professional kitchens. Next is the ice-cream layer, which was lots of fun—I used all newly acquired fabrics, many of them handpainted. The hexagons and squares represent scoops of ice cream and toppings. Second from the top is the blueberry layer. The dripping red touches in between were an afterthought to pull the quilt together, giving the whole its own integrity and demonstrating that these experiences are not rigid—they *do* overlap and affect each other. Layer upon layer of experience influenced the creative design of this quilt, and in that way Nicole and I shared a collaboration in art.

—ANGIE DAWSON WOOLMAN

ANGIE DAWSON WOOLMAN lives in Albany, California. She has been an avid horseperson from the age of ten, studied French and music in college, and has taught all three. Her father was an artist in many media, and when Angie took her first quilting course at thirty-three, the same month he died, she not only found her medium but realized that she'd been tremendously influenced by his expression and aesthetic. Her art experience began when his ended.

NICOLE PLUE recently moved to New York City, where she is pastry chef at Eleven Madison Park. She grew up in a big family, with older siblings who were good at sports and school. Nicole carved her niche as the family gourmand. She was at first timid about enrolling in cooking school, partly due to the lack of female role models, but soon realized she had nothing to lose. She immediately gravitated to pastry-making for its independence, autonomy, and creativity.

Index of Chefs & Artists

For more information write for
a free catalog from:
C&T Publishing, Inc.
P.O. Box 1456
Lafayette, CA 94549
800-284-1114
http://www.ctpub.com
email: ctinfo@ctpub.com

The Cotton Patch Mail Order
A Complete Quilting Supply Store
3405 Hall Lane, Dept. CTB
Lafayette, CA 94549
e-mail: cottonpa@aol.com
800-835-4418
925-283-7883